IMAGES
of America

LOST AMUSEMENT PARKS
OF THE NORTH JERSEY SHORE

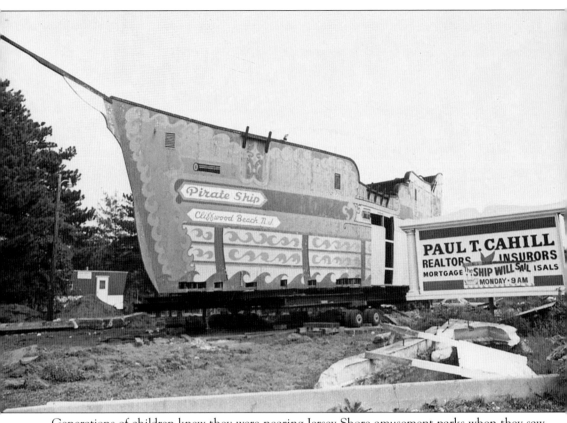

Generations of children knew they were nearing Jersey Shore amusement parks when they saw the "Pirate Ship" on Highway 35 in Cliffwood Beach. When it was Morrisey & Walker Realty, coauthor Rick Geffken and his sister Nancy called it "Pop-Pop's ship," after their grandfather Al Morrissey. This picture was taken just before it "sailed" across the highway in 1971. It burned down in 1993. (Courtesy of Dorn's Classic Images.)

On the Cover: Bill Malick (left) and Vito Petrero walk along the Asbury Park boardwalk in 1955 (also seen on page 73). (Courtesy of Dorn's Classic Images.)

IMAGES
of America

LOST AMUSEMENT PARKS
OF THE NORTH JERSEY SHORE

Rick Geffken and George Severini

ARCADIA
PUBLISHING

Published by Arcadia Publishing
Charleston, South Carolina

Printed in the United States of America

Library of Congress Control Number: 2016960611

For all general information, please contact Arcadia Publishing:
Telephone 843-853-2070
Fax 843-853-0044
E-mail sales@arcadiapublishing.com
For customer service and orders:
Toll-Free 1-888-313-2665

Visit us on the Internet at www.arcadiapublishing.com

*This book is dedicated to children of all ages who enjoyed
and remember the best times of their lives.*

CONTENTS

FOREWORD

Amusement parks came in so many formats, but all possessed a universal appeal of fun and frolic, uninhibited by the constraints of everyday life. Usually outdoors and most-often enjoyed in warm weather, their greater attraction was to youth—not merely the young, but also the young at heart. Those who enjoyed amusement parks in their youth invariably return for a trip through the world of nostalgia.

The New Jersey Shore, a special place in the recreation world for "fun in the sun," begins in Monmouth County. Numerous towns line the state's waterfront where the approaches to the ocean shore actually begin on nearby estuaries and bays. Even the routes thereto became part of the trip, especially the sight of the Highway 35 Pirate Ship, which served as the young traveler's beacon to "almost there."

Each town, from blue-collar Boynton Beach to Methodist Ocean Grove, possessed a unique character. Many parks offered similar rides, the inevitable merry-go-round and the other spinning platforms where the shape of the enclosure could transport the rider on a teacup into wonderland or on a rocket ship to outer space. Some features were clearly named, such as the miniature golf so popular in Asbury Park. Other names were inexplicable, such as the "Dodge'em," the bumper cars where crashing into one another was the name of the game. An entire boardwalk could constitute one "park," while another could be an enclosed shelter or building. All served as avenues to summer adventure.

Some amusements remained timeless, while others reflected the spirit of their era, such as the current fashion to get soaking wet in water parks. In the 1950s, as families hit the roads searching for new suburban housing, theme parks opened for short stays on highways. The well-documented Storyland Village lasted only nine years, the mysterious Jersey Jungle for perhaps fewer.

We visit amusement parks twice, first in real time, then in retrospect. My youthful self was there, so I know. I also enjoyed a nostalgic trip via Rick and George's fine volume; it is time travel that will rekindle your youth.

—Randall Gabrielan
Monmouth County Historian

ACKNOWLEDGMENTS

We could only have completed this book with the special help, advice, and contributions of many personal friends, librarians, community archivists, and the members of local historical societies. We wish to thank all these contributors (with apologies to anyone we may have inadvertently omitted): Robin Blair, Betty Bono, Don Burden (Shrewsbury Historical Society), Russell Card, Chris Cavallaro, Jay and Betsy Cosgrove, Floranne Foley (Sewaren Library), Lynn Fylak (Atlantic Highlands Historical Association), Randall Gabrielan, Susan Sandlass Gardiner, Mary and Jim Geffken, Janice Grace (Long Branch Public Library), Walter Guenther (Historical Society of Highlands), Bob Hopkins, Rock Hopkins, Bill and Porter Keller, Joel Lemansky, Lisa Lamb (Side O' Lamb.com), Don Lewis (Bradley Beach Historical Society), Kate Mellina, Patricia O'Keefe (Belmar Historical Society), Charles K. Paul II, Ken Pringle, Barbara Reynolds (Squan Village Historical Society), Mike Romano, Wendi G. Rottweiler (Woodbridge Public Library), Mark Sceurman (*Weird NJ*), Katie Schultheis (Historical Society of Ocean Grove), Kathy Severini, Ann Smith (Franklin Township Library), Rickey Stein, Jack and Beverly Wilgus, Linda Wilson (Monmouth County Genealogy Society), Grace Wolf, and Lisa Young.

We also appreciate the invaluable information sourced at websites for the following: *Asbury Park Press*, *Belmar Coast Advertiser*, the Boston Public Library, Dorn's Classic Images, Library of Congress, Monmouth County Archives, *New York Times*, and *Red Bank Register*.

INTRODUCTION

Ship me somewhere on the Central, somewhere on the Jersey Coast
From the Highlands down to Barnegat, the Shore that is our boast
For the summer land is calling and it's there that I would be
On the white sands of New Jersey, looking out upon the sea

—Robert Rowe Satterthwaite, 1910

For more than 130 years, merry-go-rounds, Tilt-A-Whirls, and roller coasters have spun, flipped, and twirled summer visitors to the Jersey Shore. Millions of children, enticed by saltwater taffy, candy apples, all-day-suckers, and cotton candy, and captivated by the thrill rides, have beseeched their parents to take them to the many seaside amusement parks, such as Long Branch or Asbury Park. Some kids were just as happy to enjoy miniature golf and pinball in towns like Belmar and Manasquan.

Thousands of cars drove from New York City and northern New Jersey every summer day for decades. They sped down Routes 1 and 9 or Highway 35 to Monmouth County, long before the Garden State Parkway made it easier to reach the shore in the 1950s. Some families headed to the closest of these fun parks at Boynton Beach or Keansburg. More adventuresome families kept going, to Atlantic Highlands, Highlands, or beyond.

Coney Island was known as "America's Playground" by the 1870s; it was the first amusement park of note on the East Coast. It did not take too long for New Jersey entrepreneurs—Cassimer Boynton at Sewaren and William Sandlass Jr. at Highland Beach—to imitate and improve on the Brooklyn model. These men understood that combining bathing facilities, restaurants, rides, and attractions at one location would lure people. Within a few years of opening his excursion resort at Sandy Hook in 1888, Sandlass was reporting crowds of up to 15,000 people a day. It would keep going for the next 50 years.

City dwellers had plenty of choices for amusement at the Shore, but most everyone made an annual pilgrimage to Asbury Park. Carloads thumped over the cobblestones in Deal on the way to the mecca of mirth. Beckoned by barkers, crowds flocked to saltwater taffy stands and played hundreds of arcade games of chance or rode three-wheeled wicker carriages along the famous boardwalk. Merry-go-rounds, swinging cars gliding and rotating over the sea, the Whip, trains and planes, and an endless array of spinning and spiraling rides were crowded next to one another, joining arcades with Skee-Ball, pinball, instant photo booths, and shooting galleries. Throw a ball, take a shot at a target, swing that hammer to ring that bell—each had its own distinctive sound and visceral reward. For just a few nickels or dimes, one could win a teddy bear, balloons, or what seemed like an infinite number of cheap trinkets.

The Haunted Mansion, Storyland Village, and Cowboy City were our fantasylands before Walt Disney patented the name. "Mommy, can I have?" or "Daddy, I want" were the clarion calls of

young day-trippers. We laughed our way through the Fun House, soared on the Ferris wheel, and (when we got a little older) lost ourselves in the Tunnel of Love.

Music echoed along the boardwalks from every ringtoss, knock'em down, and casino all day long and into the night. In the 1960s, teenagers drove "the Circuit" in Asbury Park while ignoring the rides that had captivated them in their grade school days. Music styles changed too over the years. Springsteen's "boys in the casino dancing with their shirts open" and "those silly factory girls" evoke our halcyon days around Asbury Park, but the same kind of kids were doing the same kinds of things on boardwalks long before we baby boomers showed up.

The interminable walk from a parked car to the rides was bearable only because the closer we got, the organ music sounded louder and our adrenalin rush intensified. At the first merry-go-round we encountered, we jumped up on horses, lions, or giraffes, but avoided those staid ornate carriages. The carousel would jolt to a start, and we would be whizzing along, waving to Mom and Dad every 30 seconds or so and feeling oh so big. Some older kid would work his way through the pulsating animals, collecting our tickets or checking our leather safety belts. Rotary rides of all shapes and sizes, bumper cars, the clickety-clack tracks of the miniature trains, and swooping roller coasters dizzied us, making us feel like we defied gravity. It was made all the more exciting because we knew we would return to earth and the safety of smiling and approving parents.

Why are so many of these fabulous fun places lost? When did all the calliopes crash to the ground? Actually, they crumbled slowly from neglect, time, and tides. Literally, time and tides. During the late 1960s and early 1970s, civil unrest in Asbury Park and other towns kept many people away. Tastes change over time. Yesterday's Skee-Ball is today's *World of Warcraft*.

The Garden State Parkway is often blamed for the demise of the North Jersey Shore amusement parks. Didn't the super highway provide easy access to more southern destinations along the Shore? True, as far as it goes, but American culture was changing rapidly during the height of amusement park popularity. Television brought mass entertainments into the comfort of our homes, and color TV, widely available by the late 1960s, allowed families to experience a kind of third-person thrill through watching variety shows like Ed Sullivan's. People still visited the Shore, but amusement parks competed with entertainment choices like multiplex movies and sports stadiums, which began to sprout up everywhere.

Natural disasters like hurricanes, nor'easters, snowstorms, and fires destroyed and disrupted many of these boardwalk paradises too. Some amusement parks were rebuilt, only to crumble again. Few regained their former glory.

We have stretched our definition of an amusement park to include smaller boardwalk attractions found at just about every Shore town in the 20th century. Some may wonder why we did not include the Keansburg Amusement Park in this book. To put it simply, it is still a viable business, never "lost," and is operated today by the third generation of the Gehlhaus family.

Our hope is that the sights we present in this book will recall, for all, the sounds of well-spent youth.

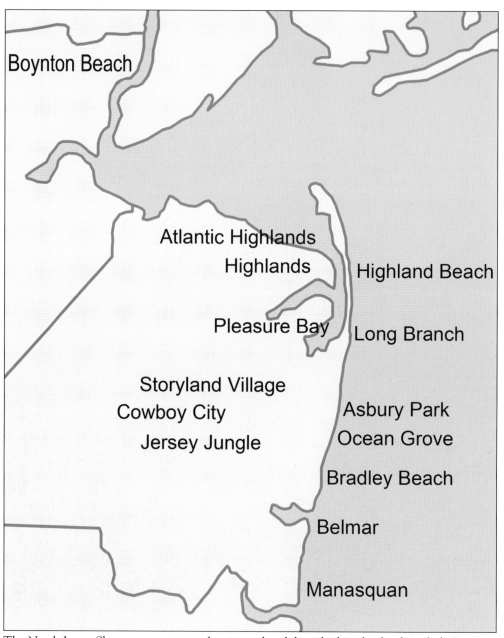

Boynton Beach

Atlantic Highlands

Highlands

Highland Beach

Pleasure Bay

Long Branch

Storyland Village
Cowboy City
Jersey Jungle

Asbury Park
Ocean Grove

Bradley Beach

Belmar

Manasquan

The North Jersey Shore amusement parks pictured and described in this book include Boynton Beach in Sewaren (Middlesex County) and 13 others in Monmouth County. (Courtesy of George Severini.)

One

GATEWAYS
BOYNTON BEACH, ATLANTIC
HIGHLANDS, HIGHLANDS

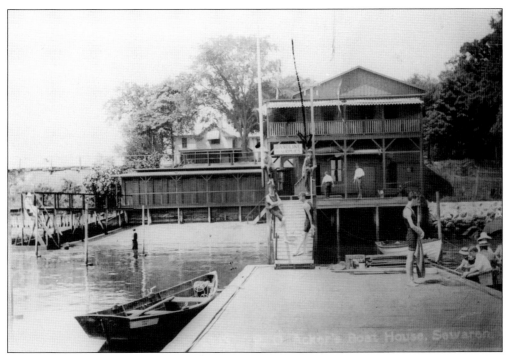

Henry Acker's Boat House was the earliest iteration of an amusement park at Sewaren in Woodbridge, New Jersey. He hired young men, who wore the one-piece bathing suits of the time, to help with rowboat rentals and act as unofficial lifeguards. Acker's ideas inspired Cassimer Boynton to create an even larger amusement park. (Courtesy of Woodbridge Public Library.)

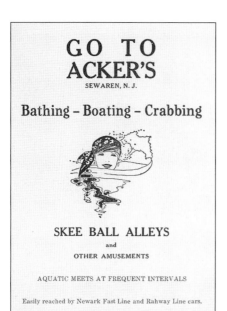

GO TO
ACKER'S
SEWAREN, N. J.

Bathing – Boating – Crabbing

SKEE BALL ALLEYS
and
OTHER AMUSEMENTS

AQUATIC MEETS AT FREQUENT INTERVALS

Easily reached by Newark Fast Line and Rahway Line cars.

In the early 1880s, Henry Acker converted his picnic grounds near his boathouse to an entertainment park offering "skee ball alleys and other amusements." The large crowds he drew to the waterfront beaches prompted other businesspeople to improve on his ideas and compete with him. (Courtesy of Woodbridge Public Library.)

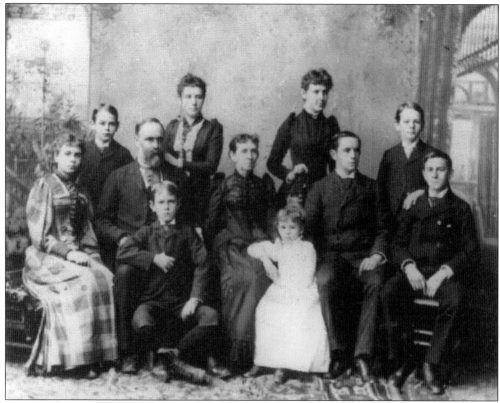

Cassimer Whitman Boynton moved from Maine to Sewaren because of its natural resources, the raw materials for his businesses. Profits from the Boynton Clay and Fire Brick Company and Boynton Lumber Company funded the resort and amusement destination he named Boynton Beach in 1877. Boynton and wife, Eunice (seated second and third from left), are pictured with their children here around 1890. (Courtesy of Woodbridge Public Library.)

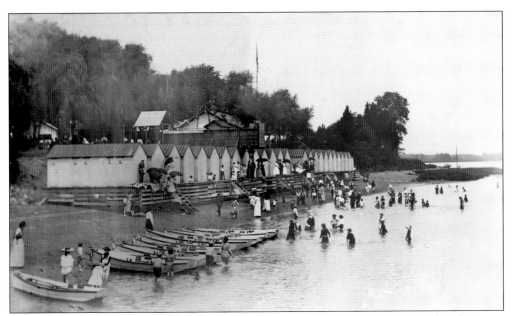

The wealthy Woodbridge, New Jersey, industrialist Cassimer Boynton competed with Henry Acker for resort customers in Sewaren. Boynton put bathhouses on the beachfront and erected pavilions and other buildings in a picnic grove behind the beach. He also purchased new rowboats to rent to his customers. (Courtesy of Woodbridge Public Library.)

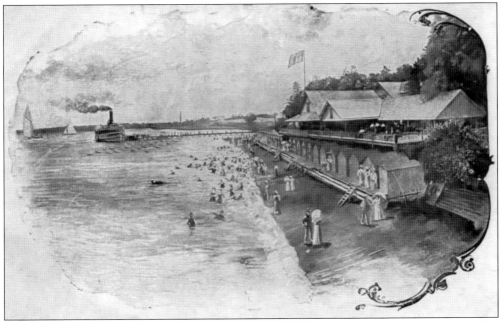

There were many amenities and amusements at Boynton Beach. Visitors arriving by steamship could indulge in swimming, convenient changing facilities, beach walks, sailing, row boating, dancing in the pavilion, fine dining, and picnicking, all while enjoying the refreshing sea breezes coming from beautiful Staten Island Sound. The Boynton Beach resort lasted until a fire destroyed it in 1916. (Courtesy of Woodbridge Public Library.)

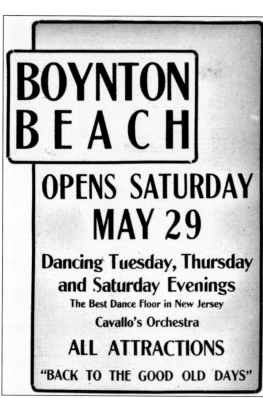

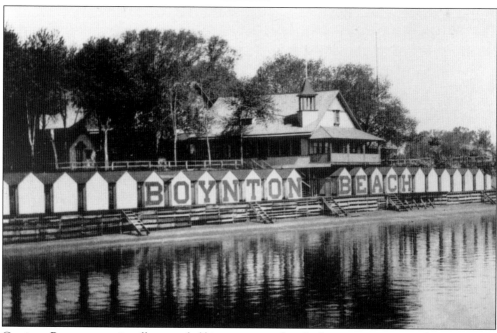

Boynton Beach was "the" place to go in Woodbridge for nighttime dancing in 1909, as this advertisement illustrates. Cassimer Boynton provided good, clean fun; no alcohol was permitted at his resort. Keen to attract customers day and night, Boynton hired orchestras to entice people to enjoy evening entertainments after day-tripping families and children left the beach. (Courtesy of Woodbridge Public Library.)

Cassimer Boynton continually upgraded his eponymous beach along extensive waterfront property. Shown here around 1895, it was a short steamboat ride from New York City and among the best-known early resorts along the Jersey coast. It had a fine restaurant, a merry-go-round, a dance hall, amusements, pony rides, a Ferris wheel, and rowboat rentals. (Courtesy of Charles K. Paul II.)

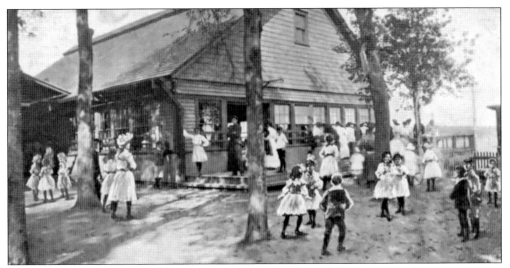

The dancing pavilion adjoining the picnic grove was one of the most popular attractions at Boynton Beach, especially on Saturday orchestra nights. Note the people peering through the windows at the dancers inside. The children in the grove frolic in imitation of their elders, as they enjoy the music too. The man on the deck with crossed arms may be supervising the youngsters. (Courtesy of Woodbridge Public Library.)

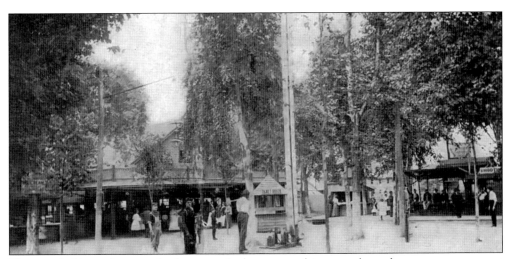

The man holding a hammer in the center is about to test his strength on the strongman game at Boynton Beach. The open-air building (left) is the dancing hall, and a shooting gallery is on the right. A ticket booth and a refreshment stand are in the background behind the trees. (Courtesy of Charles K. Paul II.)

An extensive picnic grove was a central draw at the Boynton Beach resort. Note the many buggies parked there. Folks would arrive early to secure a shady spot. No horses are visible, which suggests there was a separate barn for feeding and watering the animals, perhaps in the covered stalls in the back. (Courtesy of Woodbridge Public Library.)

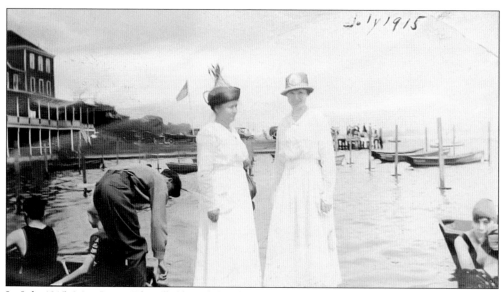

In July 1915, Mrs. James Blair (left) and daughter Lilo visited Boynton Beach and stayed at the Sewaren Hotel. An attendant bends over to help other vacationers into a rental rowboat, while two young girls on the right await their turn. The Boynton Beach dance pavilion and picnic grove are barely visible behind the automobiles. (Courtesy of Woodbridge Public Library.)

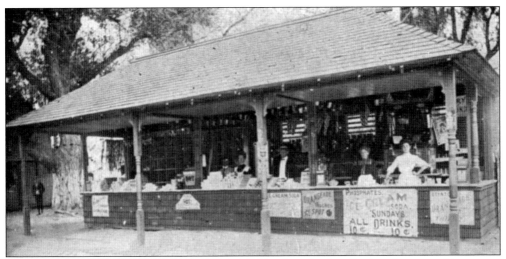

The open-air drink stand served up orangeade ("Touches the Spot"), phosphates, and ice-cream sodas for 10¢ on Sundays. The signs to the left advertise lemonade and hot dogs. The American flags decorating the stand suggest this is a Fourth of July scene from the early 1900s. (Courtesy of Woodbridge Public Library.)

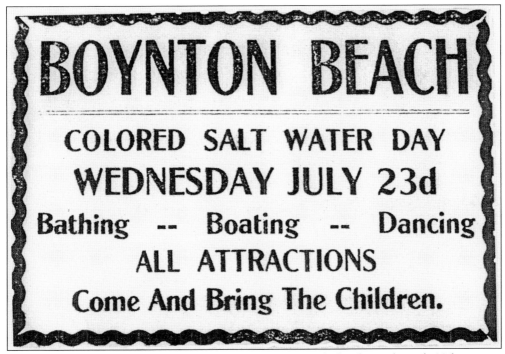

As this 1913 advertisement sadly depicts, during Boynton Beach's heyday in the early 20th century, American society was still largely segregated. African Americans were allowed to visit Boynton Beach for only one day per season and were most likely invited during the middle of the week so weekends would remain "white only." (Courtesy of Woodbridge Public Library.)

This is the only known image of the children's bamboo slide at Boynton Beach, from around 1900. The kids here seem overly dressed for such an activity; a boy halfway up is wearing a boater and bow tie. Their parents look down from the deck above in an obviously posed picture for what might be a Sunday school class visiting for the day. (Courtesy of Charles K. Paul II.)

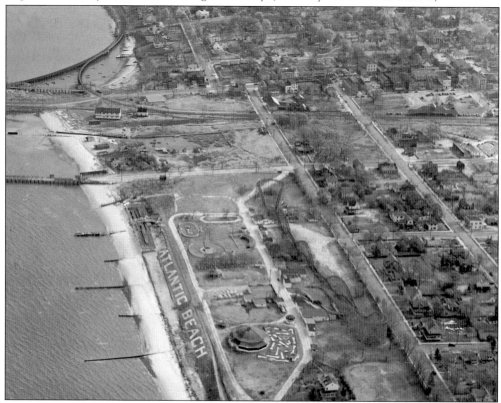

The Atlantic Beach Amusement Park was built in 1915 on Sandy Hook Bay at Atlantic Highlands. The park was between Avenues A and D, east of Bay Avenue. The merry-go-round is at lower center, with a miniature golf course to its right. The large roller-coaster tracks crossed multiple times. Its cars were powered by automobile batteries. (Courtesy of Dorn's Classic Images.)

This 1927 *Red Bank Register* advertisement introduces the public to the "New Million Dollar Amusement Park." Park owners made sure to mention its convenient location near Sandy Hook, the several nearby piers, the shorefront, free admission, and parking spaces. Note the almost modern advertising invocation of "RIDES—SLIDES—GLIDES." (Courtesy of *Red Bank Register* Newspaper Archives.)

Drive Over and Spend the Day
—AT—
ATLANTIC BEACH PARK
in Beautiful Atlantic Highlands, N. J.

Have You Seen This New Million Dollar Amusement Park?

A Place to Spend a Pleasant Day.

SHORE DINNERS, DANCING, BATHING, AMUSEMENTS GALORE FOR YOUNG AND OLD

RIDES — SLIDES — GLIDES

Including $50,000 Thriller with Ten Dips

Ellie Aeroplane, 25-car Dodgem, New Whip, Auto Ride, $35,000 Carousel, Kiddie Auto Ride, Commodious Dance Hall facing Sandy Hook. Five Beautiful Groves with canopy top tables and benches for 5,000 people. Restaurant accommodating 2,000 people. Bathing Pavilion with sanitary steel bath houses. Promenade Pier into Bay. Running Track-Ball Field.

Leading Roads to Atlantic Highlands thru Seabright and Highlands, over the beautiful hilltop into Atlantic Highlands. From Red Bank thru Rumson, over Oceanic Bridge thru the new parkway into Atlantic Highlands. This resort covers the entire shore front of Atlantic Highlands between Mandalay Pier and new Atlantic Beach Pier.

Free Admission to park and parking space for 2,000 cars.

NO REGRETS

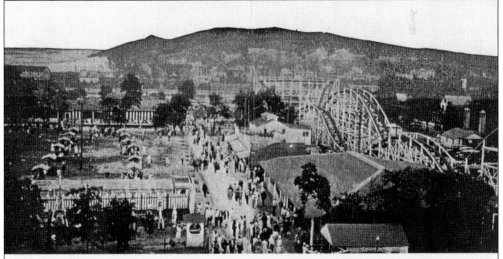

SECTION OF BEAUTIFUL ATLANTIC BEACH, SHOWING MT. MITCHELL IN THE BACKGROUND

Atlantic Beach Park was near Mount Mitchill (the name is misspelled on the postcard), the highest Atlantic coastal point south of Maine. The midway featured a carousel, "European" Ferris wheel, the Whip, Miniature Railway, Kiddie Land, Custer Car Racers, and airplane swings. Games of chance, food stands, fortune-tellers, movies, and a dance hall entertained thousands, with some arriving by steamboats. (Courtesy of Atlantic Highlands Historical Association.)

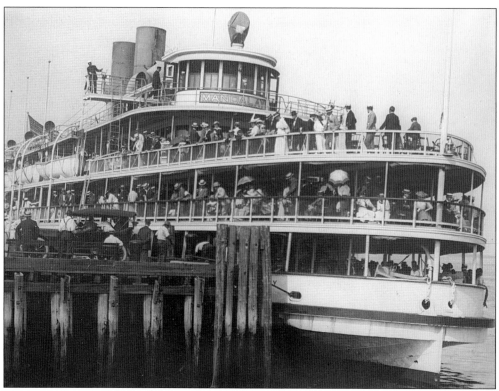

The steamship *Mandalay* sailed from the Battery in Manhattan to Atlantic Highlands and back three times a day during the peak summer season, carrying as many as 3,000 people. Shown here with passengers coming aboard after a day at Atlantic Beach Park, the *Mandalay* sank after being rammed on its return to Lower New York Bay in May 1938. (Courtesy of Dorn's Classic Images.)

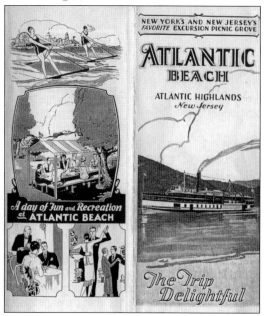

This c. 1930s advertising brochure shows the many convenient the ways to get to Atlantic Beach: by steamboat, train, or automobile. Before World War II, thousands of visitors went to the park's picnic groves and amusements. It had a 25-year run until it finally closed in 1940. Nearby competitors Keansburg and Highland Beach outlasted it. (Courtesy of Atlantic Highlands Historical Association.)

The abandoned merry-go-round stood alone for many years on the site where thousands had enjoyed it. The eyesore was eventually demolished to make way for new houses built near the Bayshore waterfront in Atlantic Highlands. (Courtesy of Randall Gabrielan.)

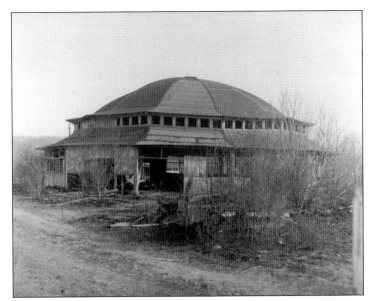

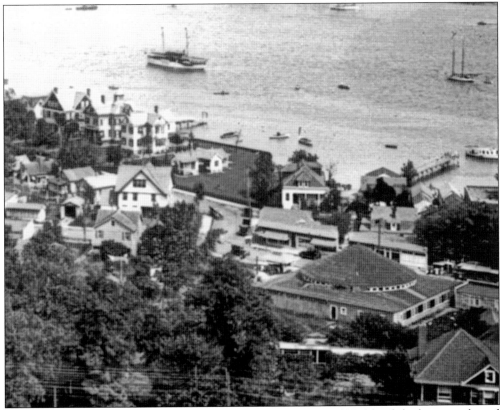

Southern neighbor of Atlantic Highlands, the riverfront town of Highlands had its own domed merry-go-round (bottom right). Built on Bay Avenue in the 1930s, this carousel is an indelible memory for summer visitors to the little community of fishermen and clammers. All kinds of watercraft are moored in the Shrewsbury River in this view from the Twin Lights. (Courtesy of Dorn's Classic Images.)

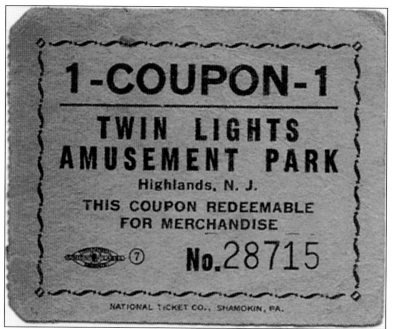

The merry-go-round is called the Twin Lights Amusement Park on this c. 1950s ticket. The name capitalized on the carousel's proximity to the highest lighthouse on the East Coast, built in 1862. (Courtesy of Historical Society of Highlands.)

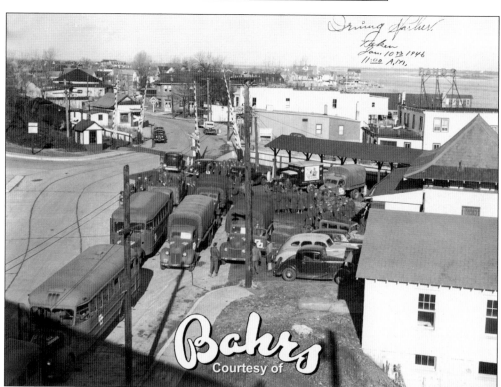

Troops are waiting at the Highlands train station on just one of the many happy days after World War II ended. The merry-go-round dome can be seen at the top left. Coauthor Rick Geffken recalls riding its wooden ponies and other painted animals during the late 1940s, trying to grab a brass ring for a free ride. (Courtesy of Bahrs Landing Restaurant.)

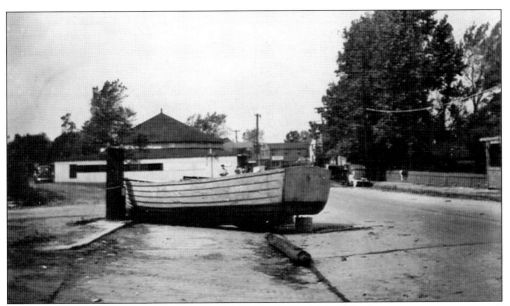

Built in the 1930s, the Highlands carousel is a precious memory for former summer visitors. A September 1944 hurricane floated this skiff up on the appropriately named Bay Avenue near the merry-go-round. The carousel went out of business in 1962, and the building was ultimately destroyed in a huge fire two years later. (Courtesy of Historical Society of Highlands.)

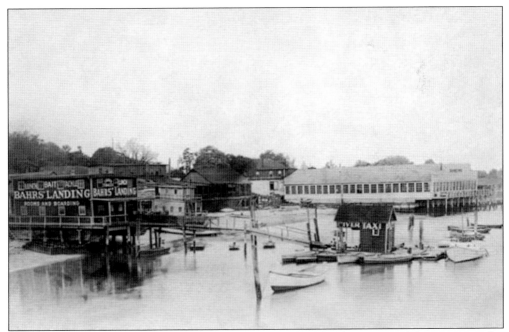

Bernard Creighton's Dance Pavilion (the long white building) was one of the most popular amusements in Highlands. It was on the Shrewsbury River, down the street from the eponymous Creighton's Hotel. A new owner renamed it Kruse's Dance Pavilion in 1915. Bahrs Landing, opened two years later, is now celebrating 100 years in the restaurant business. (Courtesy of Bahrs Landing Restaurant.)

This rare c. 1915 picture postcard shows the peanut-stone stanchions at Gravelly Point in Highlands beneath the red hills of Mount Mitchill. Jess Willard was the "Great White Hope" when he defeated Jack Johnson for the world boxing championship in April 1915. Willard's 101 Ranch Wild West Show had a temporary encampment just over the railroad tracks during its summer tour of the Shore. (Courtesy of Historical Society of Highlands.)

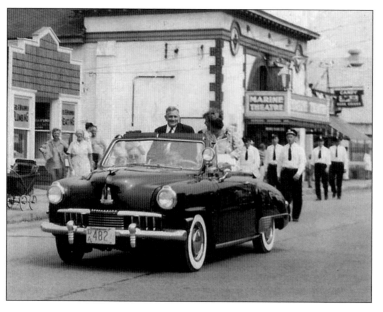

The Marine Theatre on Bay Avenue was another entertainment in Highlands. In August 1947, the famous English Channel swimmer and summer resident of the borough, Gertrude Ederle, was feted and rode past the movie theater with Mayor A. Meade Robertson. The theater building is now the Lusty Lobster seafood market. (Courtesy of Historical Society of Highlands.)

Two

CLASSIC RESORTS
HIGHLAND BEACH, LONG BRANCH,
PLEASURE BAY

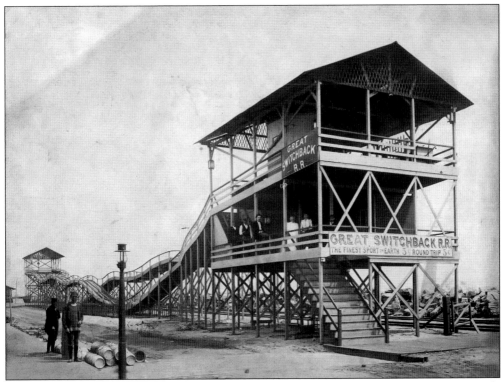

William Sandlass Jr. built the Great Switchback Rail Road at Highland Beach on the Sandy Hook peninsula in 1889. It was modeled on designs by LaMarcus Thompson, an early builder of roller-coaster rides. Thompson had installed a similar gravity railroad at Coney Island before the Highland Beach version. It was an immediate success, drawing crowds and helping launch the new resort. (Courtesy of Susan Sandlass Gardiner.)

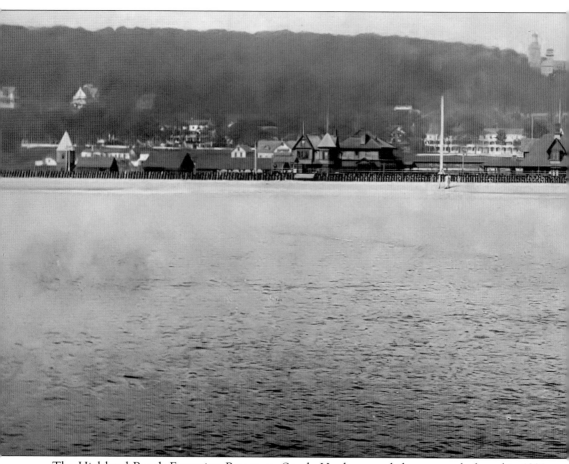

The Highland Beach Excursion Resort on Sandy Hook opened three years before this 1891 photograph was taken. The resort's Great Switchback Rail Road is on the far right. The building to its left is the Highland Beach Bathing Pavilion, and the Highland Beach Railroad Station is

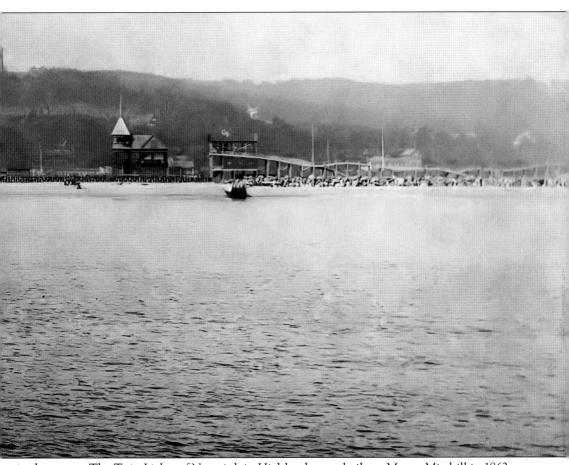

in the center. The Twin Lights of Navesink in Highlands were built on Mount Mitchill in 1862. (Courtesy of Library of Congress.)

William Sandlass Jr. was one of the true visionaries in the history of the Jersey Shore. In 1888, he signed a five-year lease with Ferdinand Fish and the Highland Beach Improvement Company. Sandlass built an "excursion resort" with bathhouses, several grand cottages, and multiple pavilions for day-tripping vacationers eager to escape the summer heat of their city homes and jobs. (Courtesy of Susan Sandlass Gardiner.)

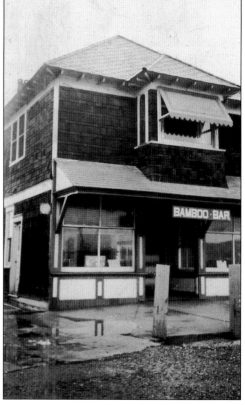

William Sandlass took down the Great Switchback Rail Road in 1893 and used its timbers to build a Fruit and Cigar Store. He added a billiards room and bowling alley to the back of the building a few years later. The Sandlass family lived upstairs. The store was converted to the Bamboo Bar in 1908. (Courtesy of Susan Sandlass Gardiner.)

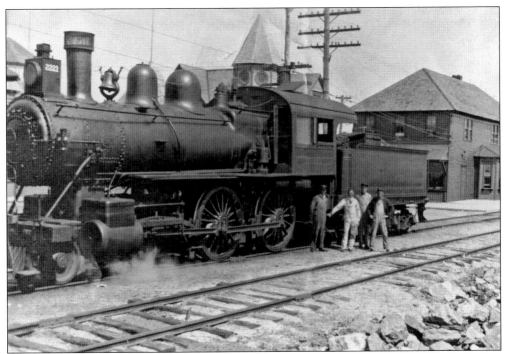

The Highland Beach Bathing Pavilion (center background) and the William Sandlass store and residence (right) are seen behind the Southern New Jersey Railroad locomotive and coal car in this 1890 photograph. The trains ran from the Sandy Hook steamboat docks to Long Branch right through his resort, forcing Sandlass to put up Caution signs to warn his guests of the danger. (Courtesy of Susan Sandlass Gardiner.)

The *New York Times* and other newspapers reported that Highland Beach sometimes drew 15,000 people a day. To accommodate overnight guests and staff, William Sandlass built the Surf House Hotel and dining room in 1891, just to the south of the bridge from Highlands (just visible on the far right). (Courtesy Susan Sandlass Gardiner.)

The Highland Beach Excursion Resort had a major impact on New Jersey transportation infrastructure. Trains arrived at the resort after 1892 via a new "criss-cross" bridge between Highlands and Highland Beach. The rail lines (left) curved south; the wooden-plank section (center) accommodated horse-drawn carriages, pedestrians, and later, automobiles. The Great Switchback Rail Road is partially obscured by the bathhouses (left background). (Courtesy of Dorn's Classic Images.)

By 1894, William Sandlass had improved the Highland Beach resort with attractions such as bathing pavilions (left), an entertainment facility with amusements, a dancing hall, a merry-go-round, and both ocean and bay beaches. He continually expanded his unique resort for decades. His family's home was the stand-alone building in the center of the narrow Sandy Hook peninsula. (Courtesy of Susan Sandlass Gardiner.)

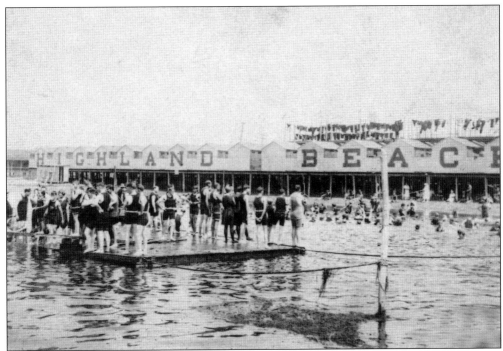

The son of a German immigrant, William Sandlass Jr. was an instinctual marketer. He provided everything his Highland Beach day-tripping guests would need—even renting blue wool bathing suits seen on the bathers on the raft. Suits waving in the sun and wind on the drying racks behind the bathhouses were a less than subtle advertisement. (Courtesy of Susan Sandlass Gardiner.)

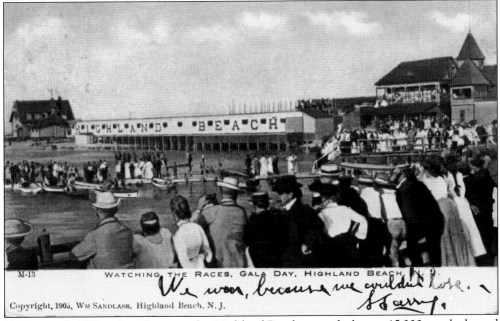

On August 3, 1895, only eight years after Highland Beach opened, close to 15,000 people showed up for Gala Day. Crowds overflowed the Shrewsbury River beach and watched the races from the bridge at Highland Beach. (Courtesy of Susan Sandlass Gardiner.)

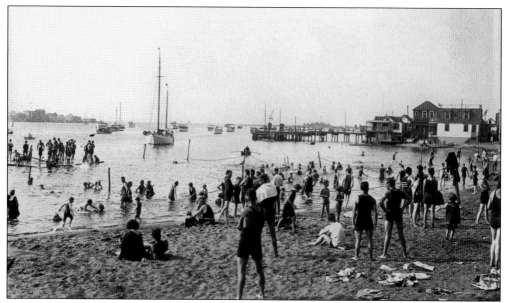

A midsummer's day crowd at Highland Beach around 1907 includes men in their rented wool bathing suits. Highlands is across the Shrewsbury River to the left. The steamboat dock leads to the bungalow colony. Bathing resorts in those days provided ropes attached to poles as a safety measure for their guests, in this case leading to a swimming platform or raft. (Courtesy of Dorn's Classic Images.)

This photograph of Highland Beach buildings was taken from the ocean side of the railroad tracks. The criss-cross bridge and Highlands are partly visible at the far left. Coca-Cola and ice-cream signs are in front of the corner store. Two "penny-scales" flank the merry-go-round seen here. (Courtesy of Susan Sandlass Gardiner.)

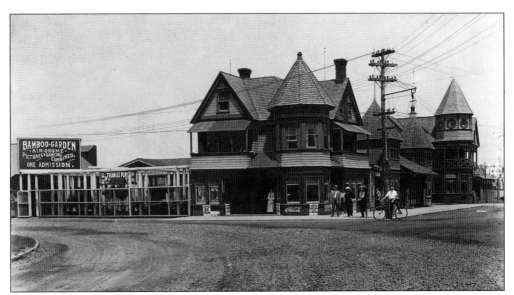

William Sandlass was intrigued with the bamboo he saw during early 1900s winter trips to Cuba and Jamaica. He had a railroad car full of bamboo shipped north to his resort at Highland Beach. The Bamboo Garden, which shared the theme with the first Bamboo Bar, had a huge palm tree in its center. (Courtesy of Susan Sandlass Gardiner.)

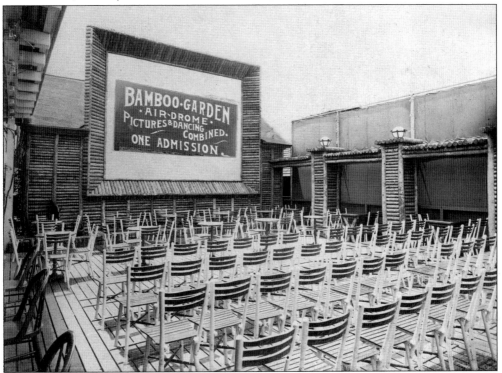

By 1915, an Airdrome Pictures outdoor theater was part of the Bamboo Garden. One admission charge entitled guests to dancing and nightly moving pictures. Daniel D. Dorn, a pioneering movie and still photographer, worked as a projectionist at the Airdrome. He also helped establish a projectionists union. (Courtesy of Susan Sandlass Gardiner.)

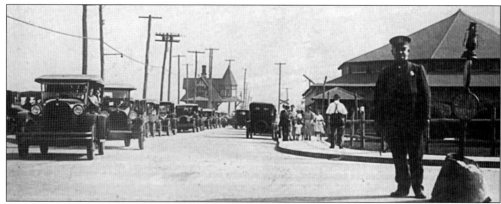

The ever-larger crowds arriving in automobiles required traffic control at Highland Beach, shown here about 1920. William Sandlass had moved the merry–go-round south, closer to a newer railroad station when he expanded and updated the pavilion buildings. Traffic cops directed the thousands of visitors to and from the Highlands Bridge and through the resort. (Courtesy of Susan Sandlass Gardiner.)

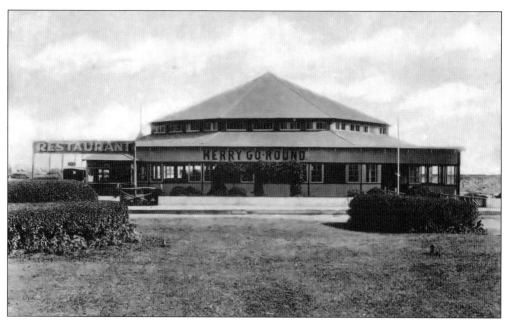

Merry-go-rounds were always the most popular rides at Shore resorts. The *Red Bank Register* reported, "Highland Beach is becoming a great Sunday resort for Red Bank people. Several hundred Red Bankers were at this resort, which is run largely on the Coney Island style. The merry-go-round was full most of the time." This is the merry-go-round with its attached restaurant around 1920. (Courtesy of Susan Sandlass Gardiner.)

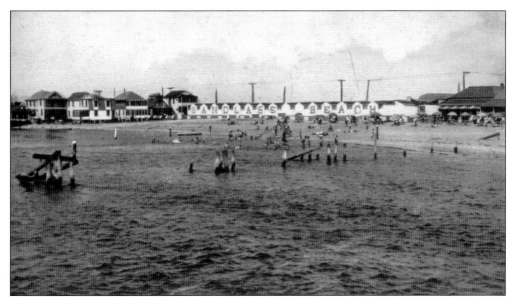

World War I, Prohibition, and the Great Depression impacted William Sandlass's Highland Beach resort. He renamed it Sandlass Beach around 1933 and began to spend time at a Virginia estate. Son Henry Sandlass took over day-to-day operations. The deteriorating pilings in the foreground of this c. 1940 picture were built to protect the 1892 criss-cross bridge from winter river ice. (Courtesy of Susan Sandlass Gardiner.)

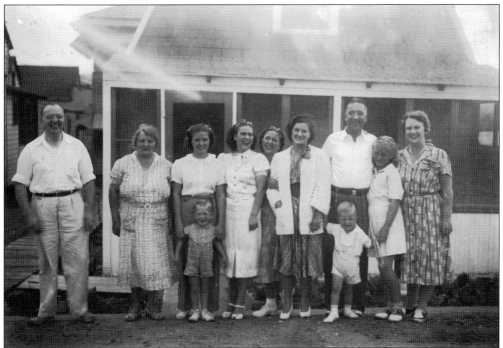

By 1935, Sandlass was leasing land for 25 bungalows to the north of the main resort and just below the federal military property. The Christy family obviously enjoys a grand time there in this 1938 photograph. The boardwalk to their left was called Dock Street and led to the river. (Courtesy of Susan Sandlass Gardiner.)

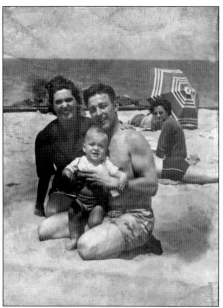

Coauthor Rick Geffken is pictured on the beach with his parents Mary and "Gip," who had both served in the US Army during World War II. In 1946, they rented a Sandlass Beach bungalow, the one nearest the Fort Hancock entrance (seen in next image). Now 96, Mary Geffken fondly remembers the wonderful musical entertainments they enjoyed on Saturday nights at the Bamboo Room Cocktail Lounge. (Courtesy of Mary Geffken.)

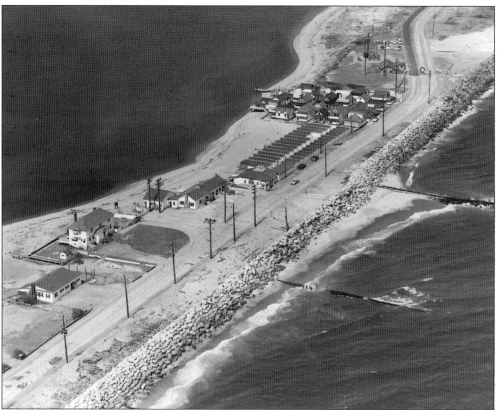

Sandlass Baths was a smaller resort by the early 1950s. The Bungalow Colony, on lots which William Sandlass leased, consisted of buildings (pictured at the top) clustered beyond the line of bathhouses. The US Army installation at Fort Hancock began just north of the bungalows at the gate leading to the dark paved road. (Courtesy of Susan Sandlass Gardiner.)

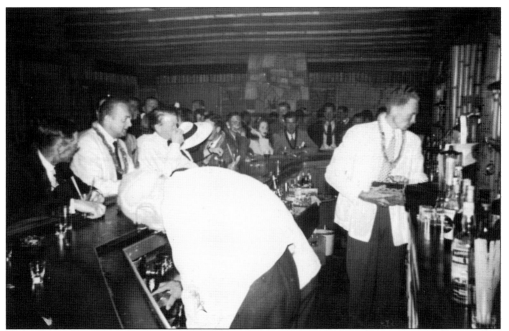

As he neared retirement, William Sandlass Jr. left the resort operation to his son Henry (on the right behind the Bamboo Room bar around 1946). The tropical-themed Bamboo Room nightclub often hosted "luaus" for its patrons during the late 1940s. Wearing imitation Hawaiian leis, the guests dressed formally in those days, enjoying their drinks and music from live bands. (Courtesy of Susan Sandlass Gardiner.)

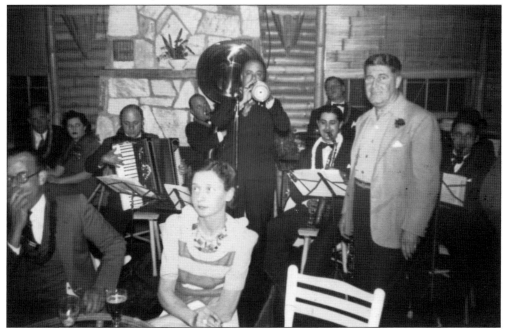

Bands entertained guests at the Bamboo Room Cocktail Lounge in the 1940s. When the lounge was closed in 1962, Henry Sandlass converted this room with its fireplace into his family's living room. (Courtesy of Susan Sandlass Gardiner.)

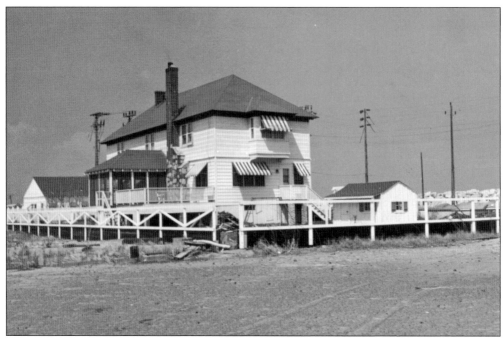

The William Sandlass House is shown here in the 1950s. By then, steamboats and trains had stopped running to Sandy Hook. When the Garden State Parkway enabled vacationers to reach Shore resorts farther south, Sandlass's business declined. Sandlass Beach finally closed in 1962, after almost 75 years of continuous family operation, when New Jersey's eminent domain procedures took the property for Sandy Hook State Park. (Courtesy of Susan Sandlass Gardiner.)

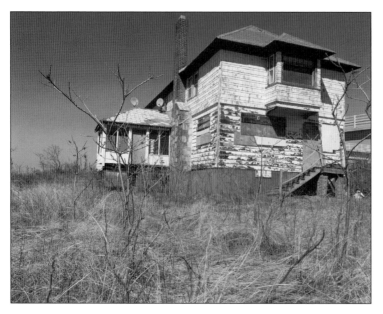

Today, this dilapidated building is all that remains of the once grand and enormously popular Highland Beach resort created by the pioneering William Sandlass Jr. Preservationists and historians have formed a group to save this 124-year-old remnant of Sandlass's entrepreneurial vision under threat of demolition by its owner, the National Park Service. (Courtesy of Rick Geffken.)

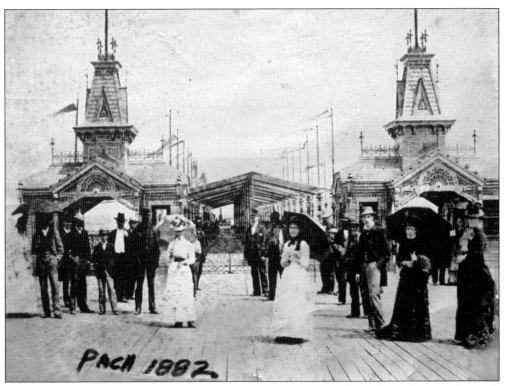

The Long Branch Iron Pier was about three years old when a Pach Brothers photographer took this picture in 1882. The pier accommodated steamboat passengers from New York. Souvenir shops, forerunners of simple amusements, were located at the shoreline end of the pier, close to the people on the boardwalk promenade built over Long Branch's then-existing bluffs. (Courtesy of Long Branch Public Library.)

This c. 1910 picture shows two famous public attractions at Long Branch: Cranmer's Baths and the fishing and amusement pier. Isaac H. Cranmer opened his bathing facilities and pavilion at Ocean and Chelsea Avenues in 1896. Locals pronounced it "Cramer's." Long Branch had a succession of ocean piers, like this one built in 1908. (Courtesy of Franklin Township Public Library.)

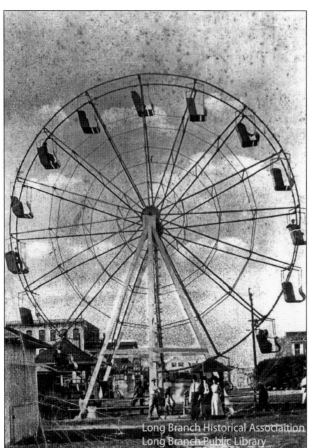

This Long Branch Ferris wheel in the 1920s is likely a temporary ride associated with a traveling carnival or circus show. It is not the one located on the amusement pier years later. (Courtesy of Long Branch Public Library.)

The New Scenic Railway, located on the New Casino lot in Long Branch, was built around 1910 by John A. Miller, who had served as chief engineer for La Marcus Thompson. Thompson created the first roller coaster in Coney Island around 1884. Miller is sometimes called the "Thomas Edison of the Roller Coaster." (Courtesy of Long Branch Public Library.)

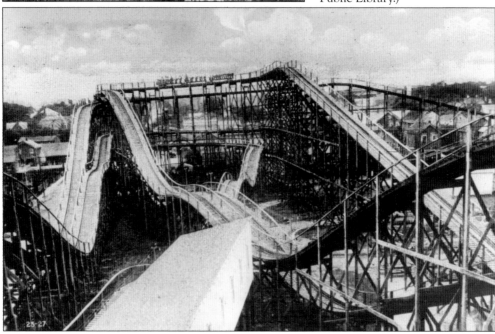

Anthony T. Woolley was the owner of a merry-go-round, shown here in 1909 before the building became a roller-skating rink. Woolley was postmaster of Long Branch from 1898 to 1910. He was also secretary of the New Jersey Mortgage & Trust Company. (Courtesy of Long Branch Public Library.)

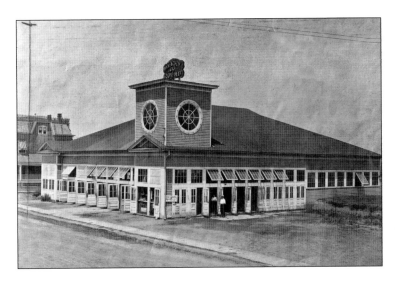

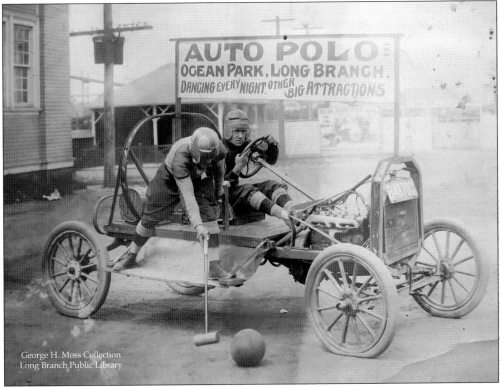

George H. Moss Collection
Long Branch Public Library

This staged picture of an auto polo team is probably a publicity photograph used to draw visitors to a match played at the 10-acre Ocean Park, which opened in 1905. Participants used automobiles instead of horses, but played the game with similar rules. The sporting fad, popular from the 1910s into the Roaring Twenties, fascinated spectators with the danger to themselves and the players and drivers. (Courtesy of Long Branch Public Library.)

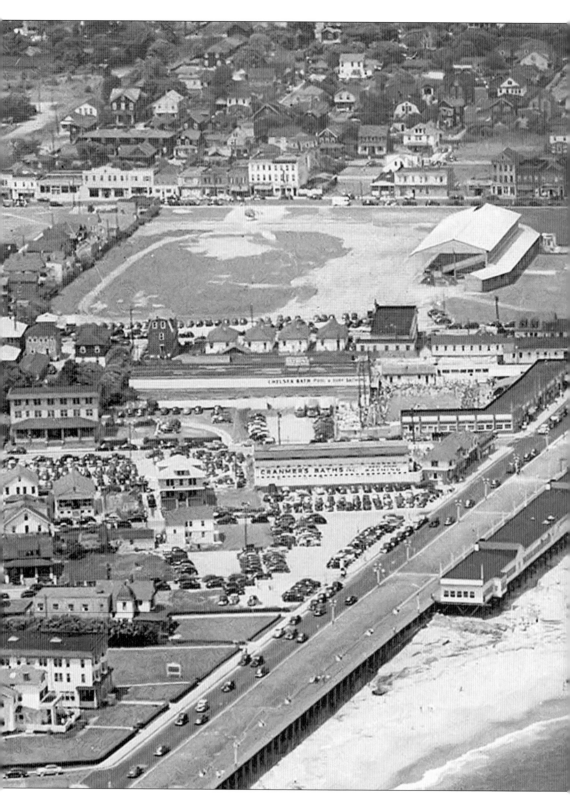

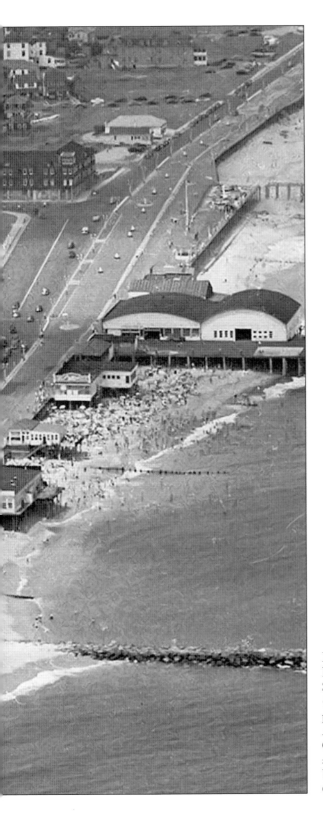

In the 1940s, the Chelsea Pool was located between the Long Branch Speedway (top) and Cranmer's Baths (the long white building with all the parked cars) on Ocean Avenue. The Amusement Pier is across from the Chelsea Pool. Food establishments and arcades line the boardwalk just below the pier. (Courtesy of Dorn's Classic Images.)

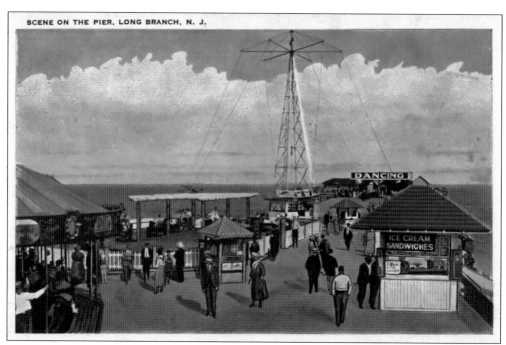

This is a view of a miniature train ride between the carousel and the flying swing ride on the pier. Outdoor dancing was always a popular pastime at Jersey Shore amusement parks. (Courtesy of Long Branch Public Library.)

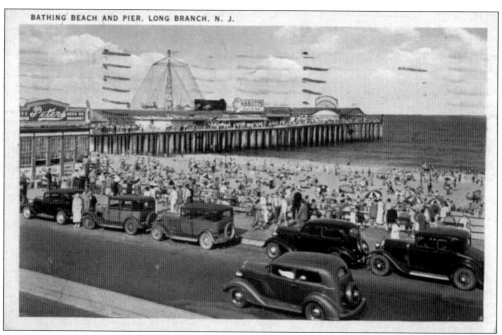

Peter's Pavilion (left) and an Abbott's ice-cream parlor were popular eateries near and on the Long Branch Pier. Besides food, Peter's sold beach-themed souvenirs toys like pails and shovels, kites, and pinwheels. The flying thrill ride resembled the Wave Swinger that would be on the pier 40 years later. (Courtesy of Long Branch Public Library.)

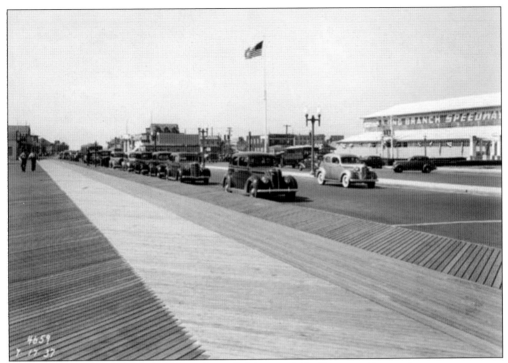

The Long Branch Speedway, or Long Branch Memorial Stadium, on Ocean Avenue, was a one-fifth-mile-long car racing track when this picture was taken in the 1930s. Between 1949 and 1951, it was a dog track known as Garfield Stadium, an odd tribute to former president James Garfield, who died in Long Branch in 1881. (Courtesy of Long Branch Public Library.)

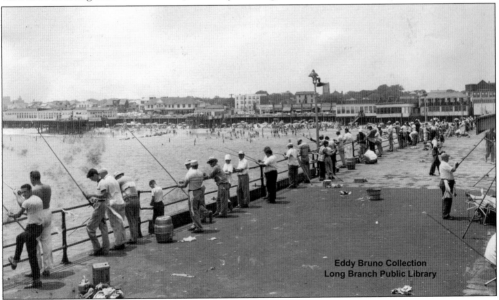

The Long Branch Fishing Pier was almost as crowded as Cranmer's Beach (center) in the 1950s. Food stands and shops lined both sides of Ocean Avenue. Coauthor George Severini recalls eating at Max's Hot Dogs—the second building from the left extending over the beach—and being served by "Mrs. Max." (Courtesy of Long Branch Public Library.)

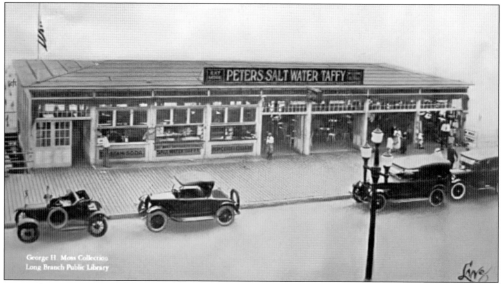

Peter's began as a saltwater taffy and soda stand on Ocean Avenue. Open to people walking the boardwalk or pulling up in automobiles, it stood in the same spot for decades and had many loyal customers. (Courtesy of Long Branch Public Library.)

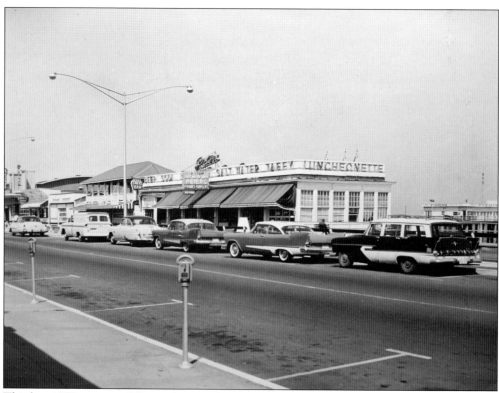

This late-1950s picture of Ocean Avenue shows Peter's Luncheonette still serving customers near the Long Branch Pier. Note the sign advertising saltwater taffy, the sweet chewy treat ubiquitous at the Jersey Shore. (Courtesy of Long Branch Public Library.)

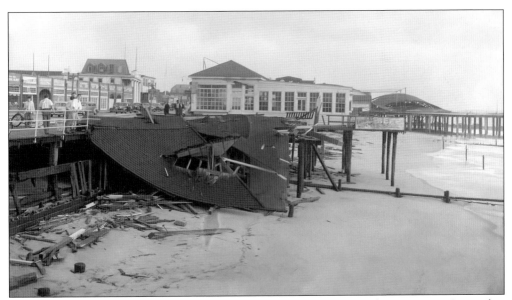

A devastating hurricane wreaked havoc on Long Branch amusement businesses on September 14, 1944. The Chelsea Avenue Pavilion is in the foreground; the collapsed merry-go-round on the pier is seen on the far right. (Courtesy of Dorn's Classic Images.)

Miniature golf was always an emblematic amusement at the Jersey Shore. During the 1960s, Long Branch real estate broker Patrick Moscatello Sr. opened Golfland-on-the Boardwalk. It stretched for several blocks, making it one of the longest such courses of its type along the coast. (Courtesy of Long Branch Public Library.)

Years later, another Long Branch miniature golf course featured an African jungle tropical theme with plastic statues of African animals, such as giraffes and ostriches. (Courtesy of Randall Gabrielan.)

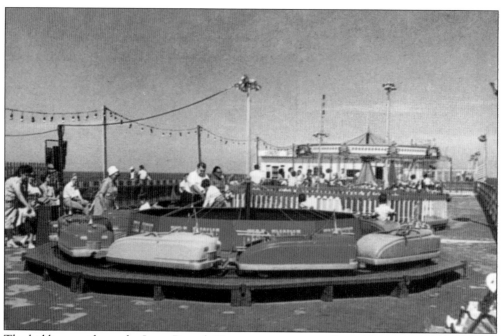

The kiddie car ride on the Long Branch Pier was next to a small merry-go-round. The image is probably from the 1950s, based on the old-time design of the cars. (Courtesy of Long Branch Public Library.)

The Long Branch Amusement Pier, located at 65 Ocean Avenue, was owned by the Sowul family from the 1960s until 1979. It was full of the swinging, dropping, gliding and sliding rides typical of all the glittering amusement parks along the Jersey Shore. (Courtesy of Long Branch Public Library.)

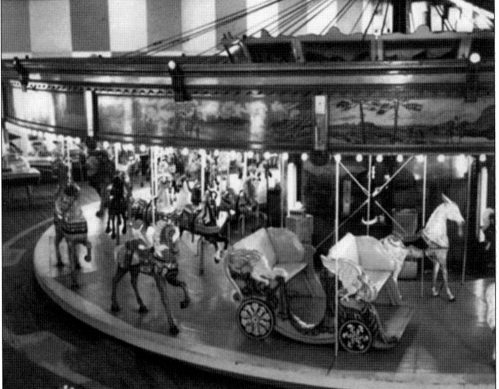

Frances and Leon Minogue owned Leon's Amusements, a penny arcade, which also had Skee-Ball, pinball, and stand-alone spinning wheel games of chance. This carousel was probably their best loved ride. (Courtesy of Long Branch Public Library.)

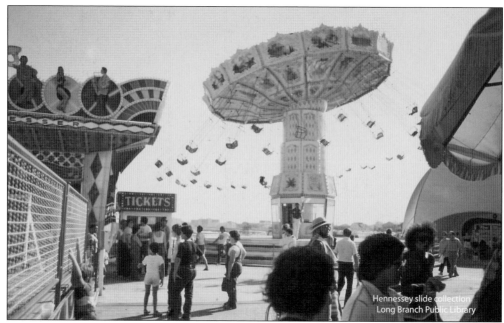

The Wave Swinger on the pier thrilled riders by spinning them out and over the ocean in single seats while it tilted and rotated at increasingly higher speeds. The Haunted Mansion was built at this location some years later. (Courtesy of Long Branch Public Library.)

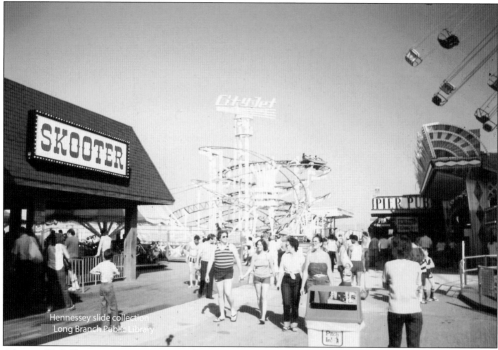

Almost 50 different amusements or rides were part of the Long Branch Amusement Pier over time. Here, Skooter is a bumper car ride near City Jet, a roller coaster. The seats of the Wave Swinger rotate through the air on the top right. Kid's World, a preteen amusement park, was built on the pier in 1985 and replaced all the earlier attractions. (Courtesy of Long Branch Public Library.)

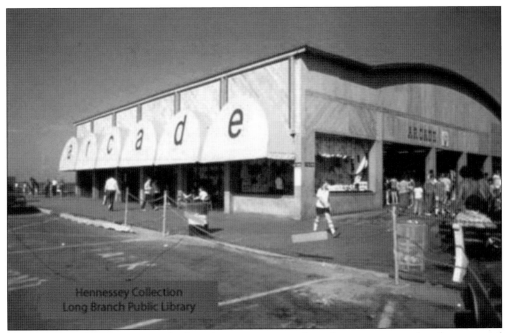

The arcade at the entrance to the Pier Amusements may have been a converted and repurposed building on the Long Branch Pier, seen here around 1960s. (Courtesy of Long Branch Public Library.)

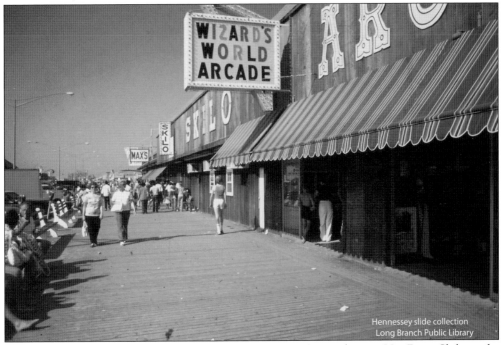

During the 1960s, the boardwalk at the Long Branch Pier featured Max's Hot Dogs, Skilo, and a pinball player's paradise called Wizards World Arcade. Max Altman opened Max's Jumbo Franks in 1928 on the pier. When Milford Maybaum bought it from Altman in 1950, he became known as "Mr. Max." (Courtesy of Long Branch Public Library.)

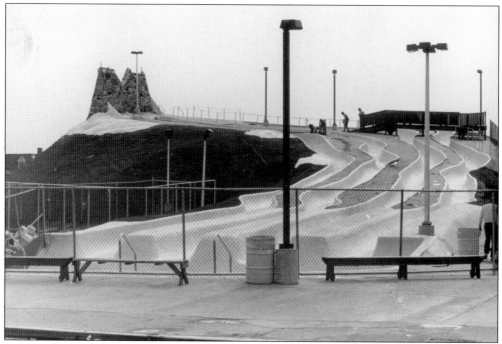

Pat Cicalese built a water park opposite the Long Branch pier on the former location of the Chelsea Pool. Bathers slid down several chutes to a wading pool. The Pier Village condo and restaurant complex opened in 2005 on the former site of the waterslide. (Courtesy of Randall Gabrielan.)

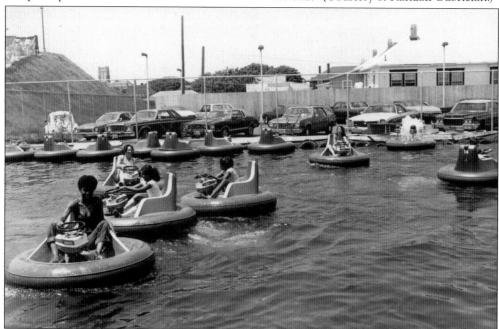

"Bumper Boats" TV commercials drew thousands to this unique water attraction, and to the "Thrill a Second" giant waterslide (top left). Both survived the 1987 fire; they were on the west side of Ocean Avenue, not on the Long Branch Amusement Pier itself. Nonetheless, they lost business and closed after the fire. (Courtesy of Randall Gabrielan.)

Helped by frequent advertising in the New Jersey/New York media market, the 10,000-square-foot Haunted Mansion on the Long Branch Pier attracted 100,000 visitors a week once it opened in 1978. It was the vision of the waterslide owner and operator Patsy Cicalese. (Courtesy of Long Branch Public Library.)

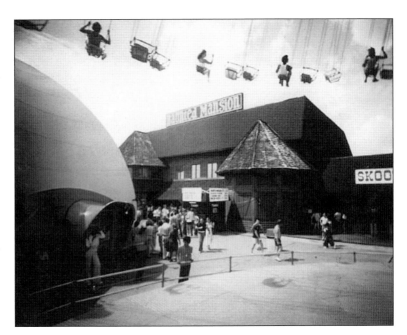

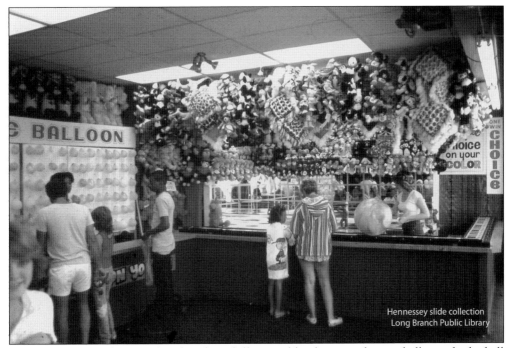

Arcades drew crowds to try their hands at skill games like throwing darts at balloons, basketball free throws, shooting galleries, and the like. The large but inexpensive stuffed animals and dolls are the alluring prizes shown here hanging over the heads of the barker and the contestants. (Courtesy of Long Branch Public Library.)

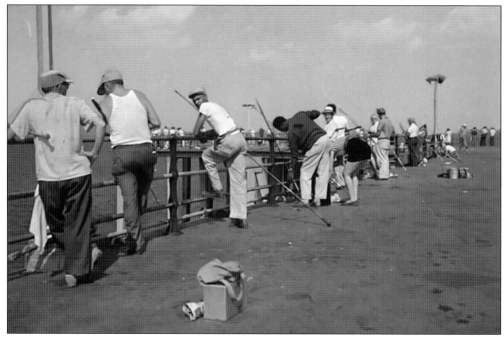

The Long Branch Fishing Pier was owned by the Sowul family until Pat Cicalese and Carmen Ricci bought it from them in 1979. The new owners opened the Haunted Mansion and other attractions on the pier. (Courtesy of Randall Gabrielan.)

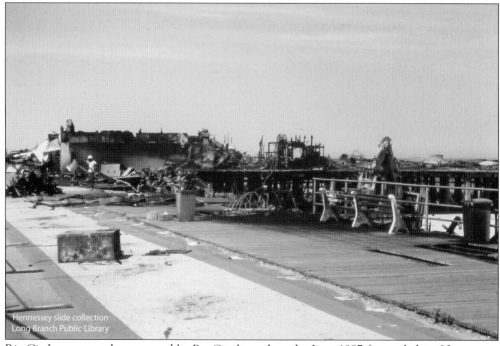

Ric-Cic Incorporated was owned by Pat Cicalese when the June 1987 fire ended an 80-year run of public entertainment on the pier. Cicalese was underinsured, and despite ambitious plans, the amusement pier was never rebuilt. (Courtesy of Long Branch Public Library.)

The Atlantic Coast Electric Railway company turned Pleasure Bay into an amusement park in 1896 to attract trolley riders from seashore communities as far south as Point Pleasant. Admission to the park was free for trolley riders. When this picture was taken a decade later, thousands were visiting the Shrewsbury River park each day, a mile or so from the ocean boardwalk amusements. (Courtesy of Long Branch Public Library.)

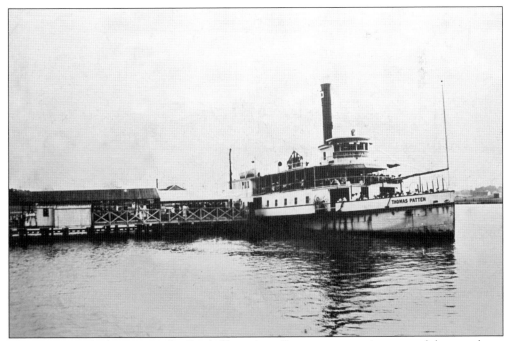

Pleasure Bay Park's location on the South Shrewsbury River was convenient to reach by steamboat. The *Thomas Patten* was perhaps the most famous of those steamboats. Here, in 1903, under the helm of Capt. Harry Edwards, it prepares to leave the Pleasure Bay dock for New York. (Courtesy of Long Branch Public Library.)

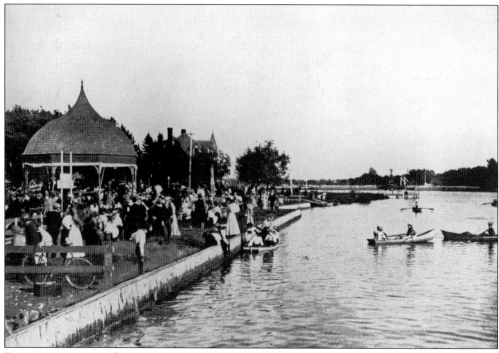

Excursion parties to Pleasure Bay Park could rent rowboats and electric launches to cruise on the South Shrewsbury River. Gondola rides were added later. Grass-covered picnic grounds and small pavilions were adjacent to the river. (Courtesy of Long Branch Public Library.)

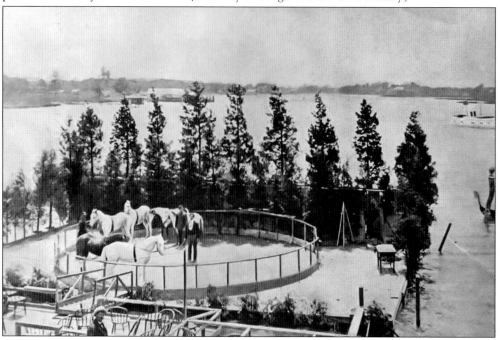

The trained horses at Pleasure Bay Park were paraded around on a floating dock. They look more like a circus act here, although the ramp leading from the stands might indicate guests could actually ride the horses. (Courtesy of Long Branch Public Library.)

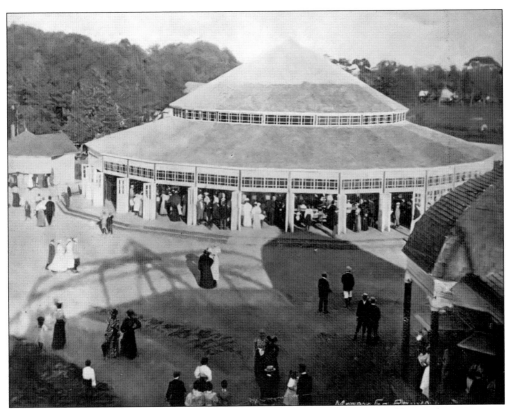

At 102 feet in diameter, the giant carousel at Pleasure Bay Park was operated by an electric motor. The building was supported by 16 varnished pine poles. Its horses were said to be "finely decorated." No doubt, riders of all ages could reach for the brass ring, which guaranteed the winner another ride for free. (Courtesy of Long Branch Public Library.)

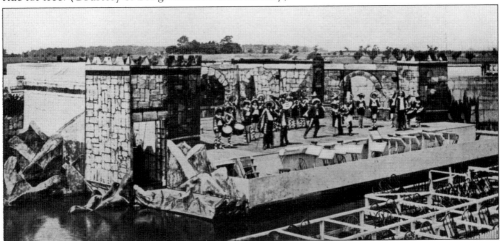

Pleasure Bay Park's outdoor Water Theater was its most popular venue. The presentation shown here with an ornate castle set might be an adaptation of Alexandre Dumas's *The Three Musketeers*. Up to 1,500 people paid 10¢ each or 15¢ for a box seat (right foreground) for plays and "entertainments of a vaudeville character." The orchestra pit was in front of the actors. (Courtesy of Long Branch Public Library.)

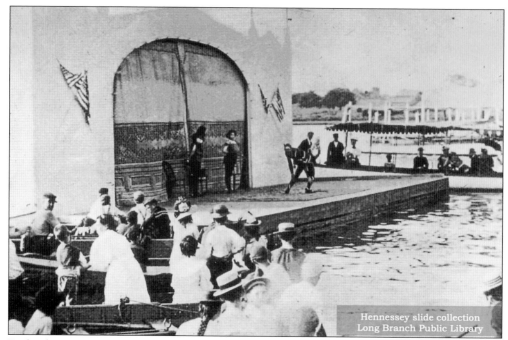

By far the most singular attraction of Pleasure Bay Park was its Water Theater. Extremely novel, the theater float was 40 feet by 50 feet, supported by empty wooden casks. Moored 25 feet away from the audience, the stage was connected to the shoreline by a floating wharf. Boaters and 1,500 grandstand guests could watch vaudeville shows twice a day, except on Sundays. (Courtesy of Long Branch Public Library.)

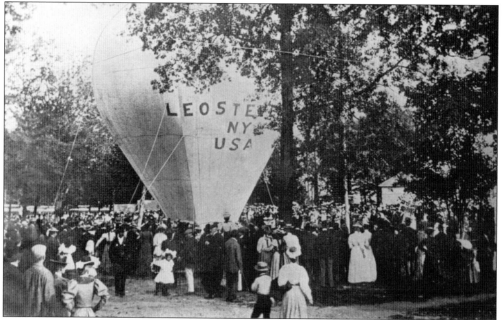

Leo Stern & Company, a hat store and haberdashery on Fourth Avenue and Jefferson Street in New York City, advertised on this hot air balloon, which offered exciting aerial rides at Pleasure Bay Park around 1904. (Courtesy of Long Branch Public Library.)

Three

TWIN CITIES
ASBURY PARK AND OCEAN GROVE

The Palace Carousel was constructed by Asbury Park carpenter William B. Stout next to Lake Avenue when it was still a dirt road. The Phoenix Iron and Bridge Company of Pennsylvania put up the observation tower for Ernest S. Schnitzler, providing his guests with gorgeous views of Asbury Park, the Atlantic Ocean, and Ocean Grove. (Courtesy of Randall Gabrielan.)

Ernest S. Schnitzler built the Palace Carousel in Asbury Park in 1888. He called it "a refined amusement for Ladies, Gents, and Children." Seven years later, a 74-foot-tall Ferris wheel and observation tower (left) was added at Lake Avenue and Kingsley Street. Here, ladies and gents head toward the Asbury Park boardwalk from Asbury Avenue in 1904, near a statue of a Civil War soldier. (Courtesy of Library of Congress.)

A swan boat on Wesley Lake sails in front of the ornate Mayfair Theater in 1958. The Palace Amusements Skooter Ride, the Ferris wheel, and the merry-go-round were alongside the U-Pedal boats in Asbury Park. (Courtesy of Dorn's Classic Images.)

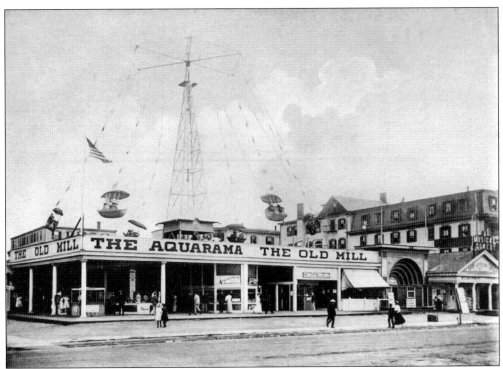

The Old Mill opened at First and Ocean Avenues in 1901. The Aquarama was a 940-foot water tunnel, through which guests navigated small boats past picturesque painted scenes. The Circle Swing on the rooftop whirled fun-seekers above and around. To the right of the Old Mill were the Gilded Entrance, the Court of Honor, and the Devonport Inn. (Courtesy of Lisa Lamb.)

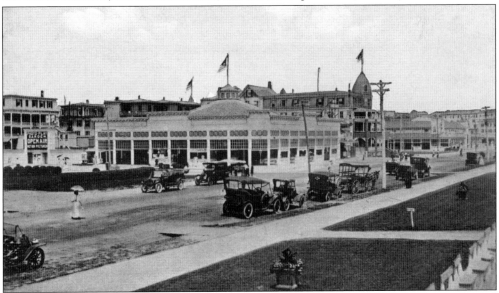

The Hippodrome Carousel was one of the many attractions that stood at the corner of First and Ocean Avenues over the years. This c. 1915 scene includes the Photo Play Garden Open Air Motion Pictures venue to the left of the Hippodrome. The carousel burned down in April 1917. (Courtesy of Lisa Lamb.)

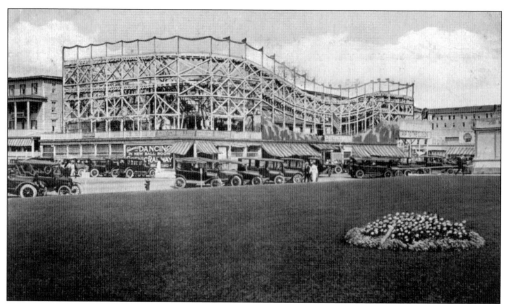

Coney Island impresario George C. Tilyou built Asbury Park's Steeplechase, where patrons raced wooden horses along undulating parallel tracks. It was later converted into a roller coaster billed as a "Trip to the Clouds." Below the superstructure, guests enjoyed ballroom dancing and roller-skating. (Courtesy of Lisa Lamb.)

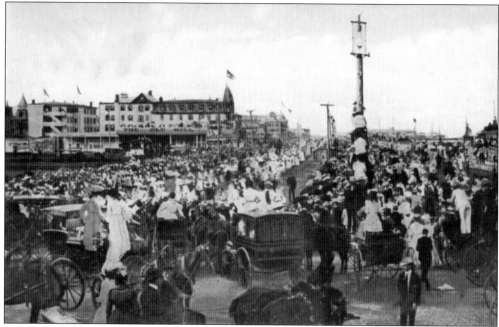

The annual Children's Carnival evolved from the popular Baby Parade, which started in 1890. Twenty years later, when this picture was taken, the carnival parade turns north onto Ocean Avenue from the boardwalk and passes the Old Mill. The carnival cost Asbury Park $13,375 in 1910. Acknowledged as one of the best events in the country, the parades lasted until 1931. (Courtesy of Kate Mellina.)

The Steeplechase is in the upper left of this picture taken from Asbury Avenue. The Natatorium is the two-story white building seen at center left. The fishing pier was at the foot of First Avenue. (Courtesy of Dorn's Classic Images.)

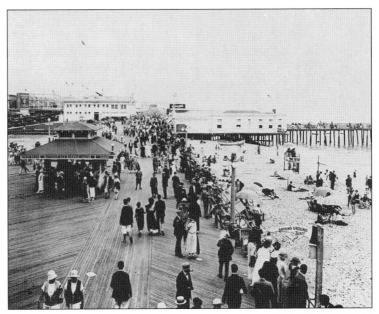

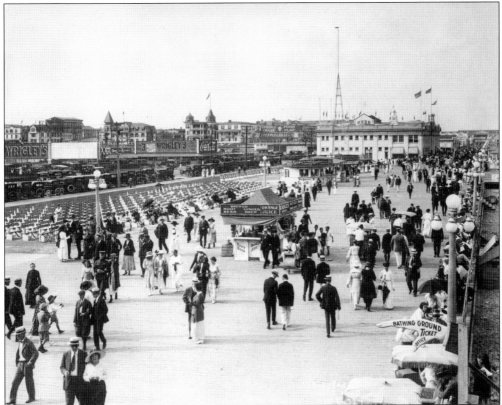

The amusements Skee-Ball and the Whip are below the Wrigley's and Coca-Cola signs in this 1919 photograph. The Steeplechase Funny Place is to their north. Boardwalk refreshment stands sold orange juice, root beer, ice cream, and milk. Several small beachfront viewing pavilions are just visible to the right of the Natatorium. (Courtesy of Dorn's Classic Images.)

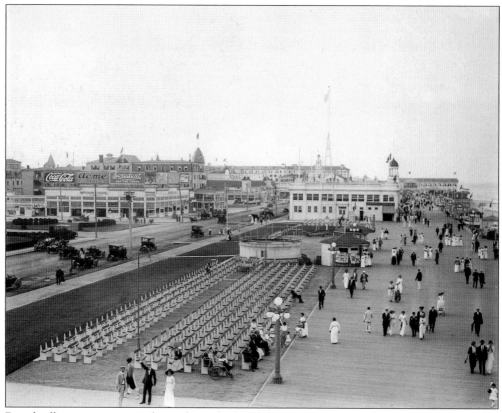

Boardwalk seats next to an elevated circular band shell faced the beach and ocean around 1915. The Orpheum Open Air Pictures and the Hippodrome Carousel were built on the site of the Old Mill. At the Natatorium (white building seen at right), "one can enjoy every day in the year a hot salt-water tub bath or a plunge in one of the finest pools in America." (Courtesy of Library of Congress.)

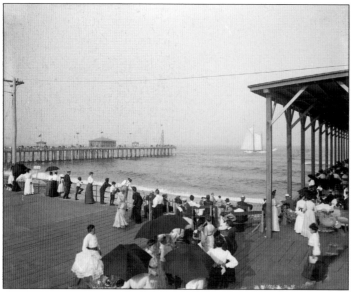

James A. Bradley developed and owned much of the oceanfront in the early days of Asbury Park. He built the fishing pier before the turn of the 20th century. In this 1905 picture, the wooden porch on the right is the Bradley Pavilion, named for the founder of Asbury Park. (Courtesy of Library of Congress.)

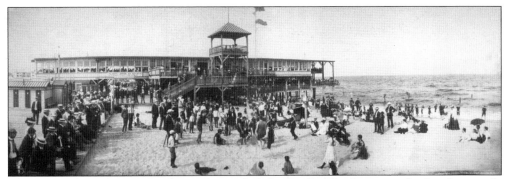

The 1873 Asbury Avenue Pavilion, often called the Bradley Pavilion, was the first large-scale building straddling the boardwalk and the beach in Asbury Park. The sign on the side of the pavilion advertises the Children's Carnival in August 1902. (Courtesy of Library of Congress.)

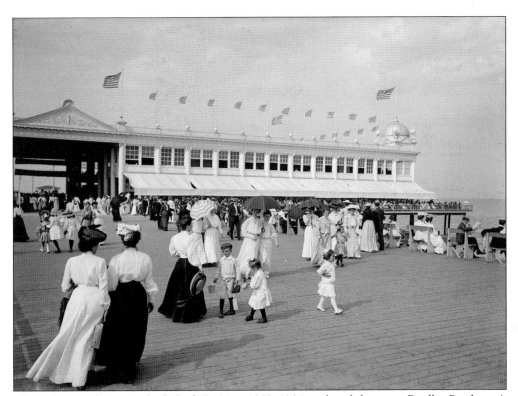

The Asbury Park Casino, built for $75,000 in 1903–1904, replaced the aging Bradley Pavilion. A "glass enclosed, two-deck building, it extended westward over the boardwalk providing an arcade lined with stores and affording a cool and spacious dancing floor," according to a newspaper account. Designer William Cottrell included statues of Atlas holding up the world. The casino burned down in 1928. (Courtesy of Library of Congress.)

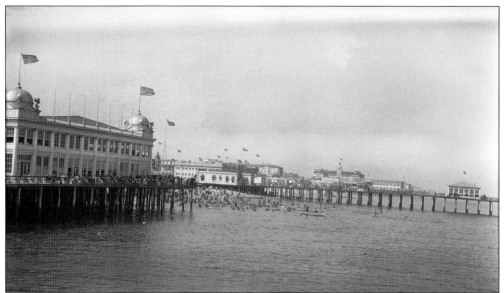

Elton Wade took this photograph of the Asbury Park Casino around 1925. A promotional brochure called it "a recreation place for the teeming thousands who promenade the boardwalk at all seasons of the year." The ornate Atlas sculptures are clearly visible at the corners. The fishing pier at the end of First Avenue reached out hundreds of feet over the ocean. (Courtesy of Franklin Township Public Library.)

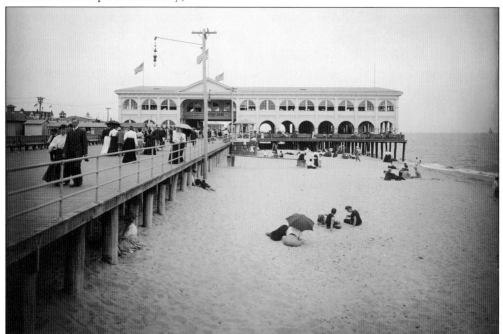

Built in 1903, the two-story Fifth Avenue Arcade extended from the boardwalk, over the beach to the ocean. A newspaper article read, "The numerous arch-ways disclosed are lighted by myriad electric globes which give to the beautiful structure at night the appearance of a blazing square." The sign over the pedestrian pathway in 1910 advertises Arthur Pryor's Band tickets for 15¢. (Courtesy of Library of Congress.)

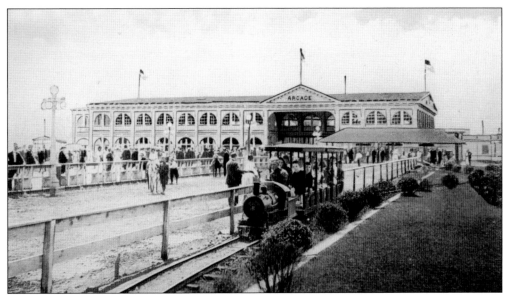

A pony track and a miniature railroad for children were next to the boardwalk on the north side of the Fifth Avenue Arcade, which was lost in a 1927 fire. (Courtesy of Lisa Lamb.)

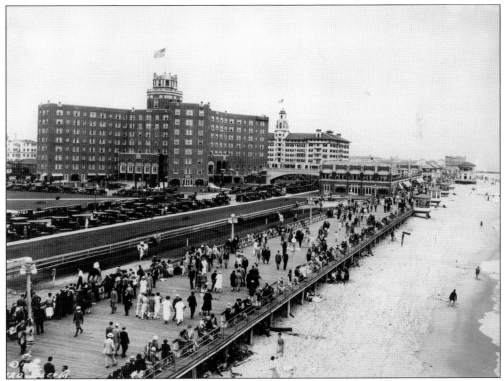

The pony ride was south of the Solarium stores in 1926. The large white building in the top center is the Monterey Hotel. "Ben Bernie Himself" was on the overpass leading to the Berkeley Carteret Hotel. "The Old Maestro" Bernie played the Berkeley Carteret with his dance orchestra during that entire summer season, just a year after he, Maceo Pinkard, and Kenneth Casey composed "Sweet Georgia Brown." (Courtesy of Dorn's Classic Images.)

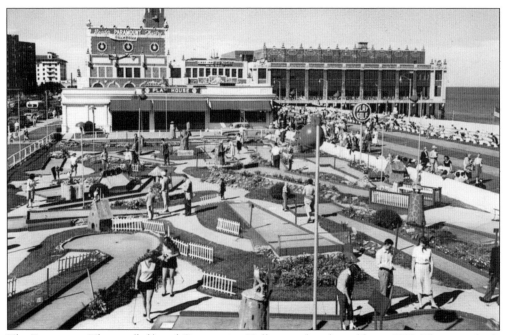

The Paramount Theater (left) and Convention Hall opened to the public in 1930. They were built where the Fifth Avenue Arcade had stood before the destructive fire. The large Play Golf course was a favorite boardwalk pastime, as seen here in 1955. (Courtesy of Randall Gabrielan.)

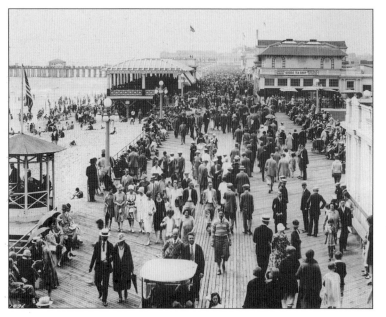

Essential elements of Asbury Park's boardwalk attractions in 1926 were a wicker carriage (foreground), beachgoers, a small octagonal seating pavilion (left), a larger band pavilion, the fishing pier, the casino (distance), the Natatorium (right), Goodie's Tea Shop at Fourth Avenue, and a bathhouse. (Courtesy of Dorn's Classic Images.)

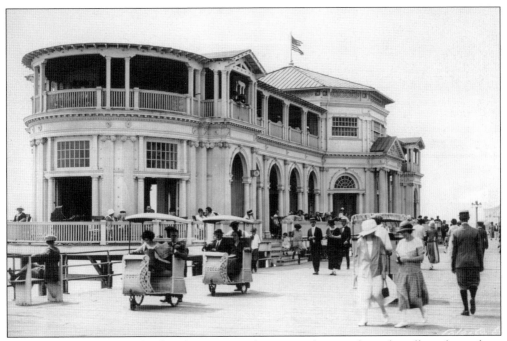

This closer look at three-wheel wicker carriages shows attendants pushing the rolling chairs along the boardwalk. They are passing the Seventh Avenue Pavilion, nicknamed the "Birdcage" for its distinctive rounded edges. (Courtesy of Dorn's Classic Images.)

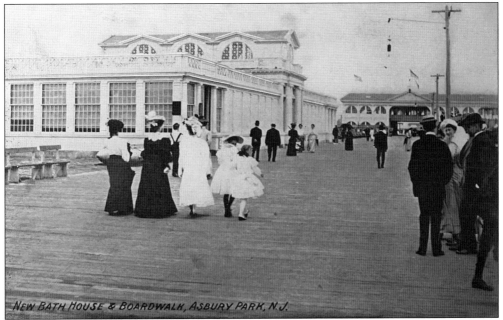

This bathhouse (left) was adjacent to the Fifth Avenue Arcade (right). The *New York Times* reported on June 16, 1907: "Bathing started in today with a vim. The new and modern bath houses recently completed by the city were opened, and there were hundreds of bathers. Beginning this week, free afternoon and evening concerts will be given at the Arcade on the Boardwalk." (Courtesy of Lisa Lamb.)

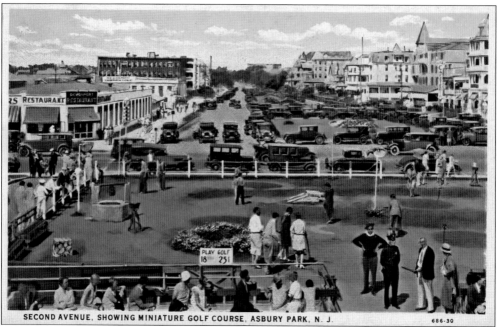

SECOND AVENUE, SHOWING MINIATURE GOLF COURSE, ASBURY PARK, N. J. 686-30

This 1930s image shows a miniature golf course on the boardwalk at a time when playing 18 holes cost a quarter. The Devonport Restaurant's entrance (left) at Second and Ocean Avenues may look familiar to present-day fans of live rock music. John and Ida Jacob ran the Devonport, which became well known as Mrs. Jay's in the 1940s and is now more famous as the Stone Pony. (Courtesy of Boston Public Library.)

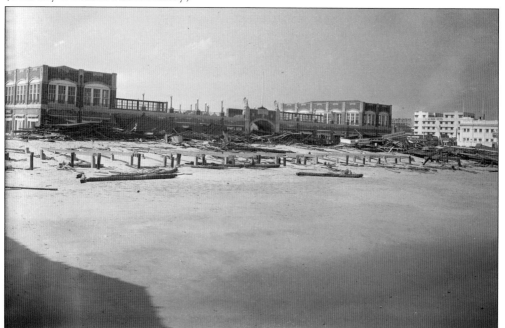

The boardwalk in front of the South Solarium was totally destroyed by the 1944 hurricane, the most disastrous storm in Asbury Park's history. It took the city two years to rebuild and open the boardwalk to the public. (Courtesy of Dorn's Classic Images.)

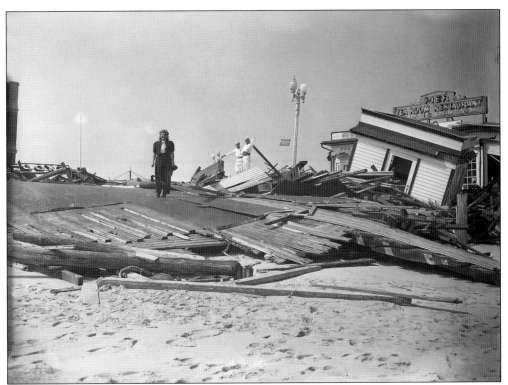

The massive destruction caused by the hurricane of September 1944 ruined many boardwalk businesses. All that was left of Gus Sareotes's Pier Tea Room was the facade of his restaurant. His granddaughter Diana Alikas recalled stories about the restaurant's safe washing up several days later. (Courtesy of Dorn's Classic Images.)

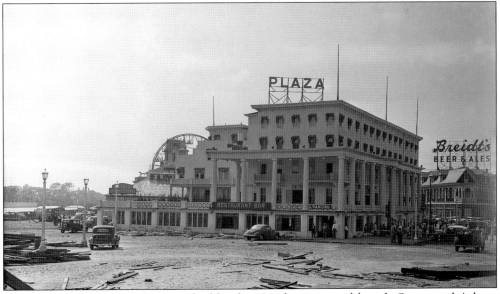

The Plaza Hotel was largely unscathed by the 1944 hurricane, although Ocean and Asbury Avenues were strewn with wreckage. The Palace Amusements Ferris wheel also survived the storm. (Courtesy of Dorn's Classic Images.)

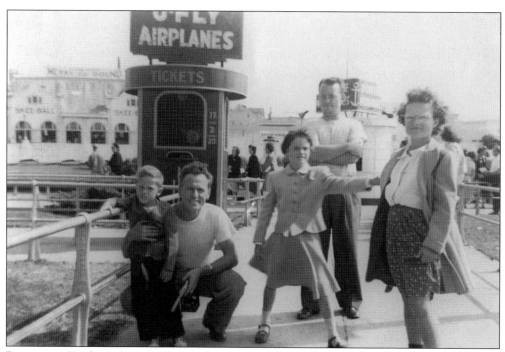

Posing near Wesley Lake in 1951, from left to right, Philip "Tinker" Dorn, Dan W. Dorn Sr., and Patricia "Trish" Dorn are joined by two unidentified family friends. They are standing in front of ticket booths for the U-Fly airplane ride and U-Pedal boats. The merry-go-round and Skee-Ball arcades in the background are in Ocean Grove. (Courtesy of Dorn's Classic Images.)

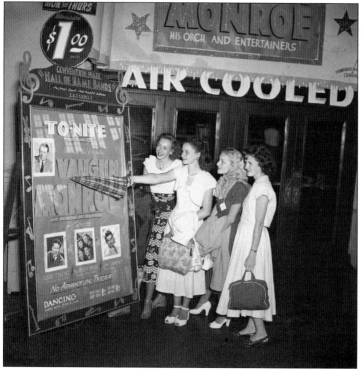

Vaughn Monroe and his Orchestra and Entertainers appeared at Convention Hall every year from 1945 to 1952. These four young ladies obviously worshipped the musicians. The words on the frame read "Hall of Name Bands. New Jersey's Largest—Most Beautiful Ballroom." (Courtesy of Dorn's Classic Images.)

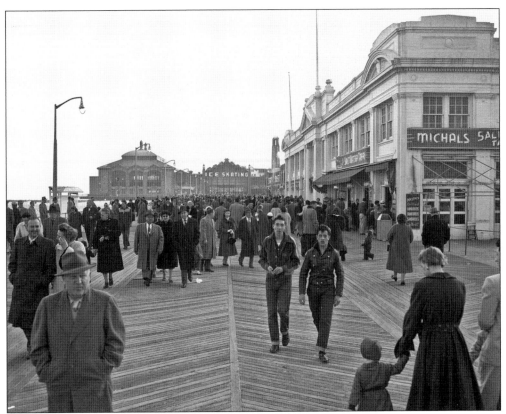

The 1955 crowd gave Bill Malick (left) and Vito Petrero a wide berth as the 15-year-old boys sported greaser haircuts and motorcycle jackets while they cruised the boardwalk. Ice-skating was the attraction at the casino, built in 1929 for $2 million. Michals Salt Water Taffy store, in the former Natatorium, was one of several Asbury Park restaurants owned by the Michaelapolis family. (Courtesy of Dorn's Classic Images.)

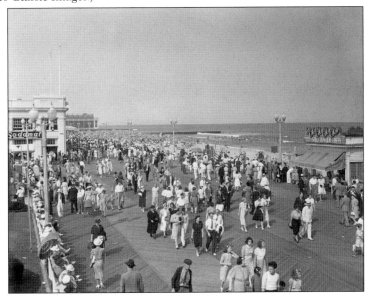

Boardwalk strollers could stop for a refreshing drink at the Sodamat, or buy emblematic saltwater taffy during their visits to Asbury Park on a calm late-spring afternoon in the 1950s. (Courtesy of Dorn's Classic Images.)

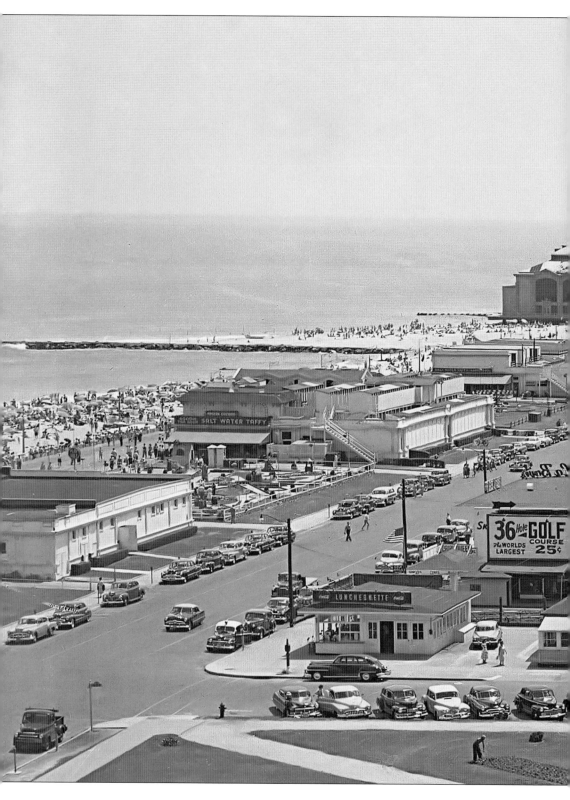

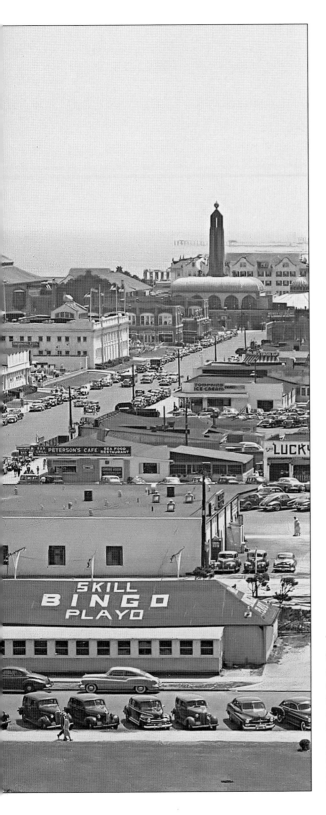

Taken from the roof of the Berkeley Carteret Hotel around 1953, this view of Asbury Park looks south toward the casino. The glimpse of lawn in the foreground is Bradley Park, opposite Convention Hall (not shown) along Ocean and Fifth Avenues. Today, the Wonder Bar is on the site of the Luncheonette and the Skill Bingo Playo in this picture. (Courtesy of Dorn's Classic Images.)

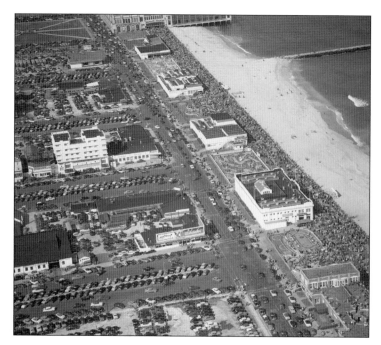

This view of the Asbury Park Boardwalk on a weekend in 1953 attests to the resort's peak popularity during that decade. Thousands of people walk from Convention Hall to the Solarium, passing the kiddie rides, miniature golf courses, the Natatorium, and other amusements. Every parking space for blocks is full. Bars, restaurants, and the Albion Hotel (left center) were doubtless packed as well. (Courtesy of Dorn's Classic Images.)

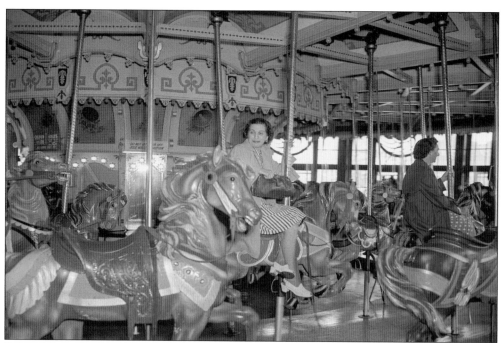

Even adults rode the Casino Carousel on a 1950s afternoon in Asbury Park. A half circle of one of its decorative medallions is to the left of the woman in the dark coat. (Courtesy of Dorn's Classic Images.)

The casino merry-go-round was built in 1932; it was the last carousel made by the Philadelphia Toboggan Company. New York Beaux-Arts architects Whitney Warren and Charles Wetmore designed the copper and glass facade with medallions of the face of the Roman god Mercury, a representative of speed. (Courtesy of Grace Wolf.)

The Asbury Park Boardwalk near Wesley Lake had (from top to bottom) two arcades, the Natatorium, the south Solarium (opposite the Empress Motel), and the casino complex with the dome-topped carousel on the left. Kiddie rides are next to the carousel and the heating plant tower. The lower buildings are in Ocean Grove. (Courtesy of Dorn's Classic Images.)

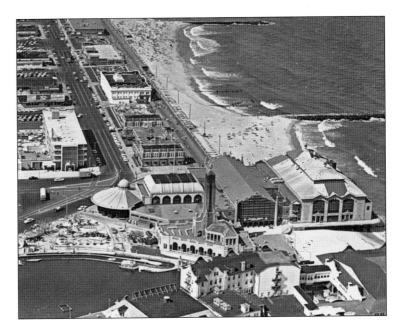

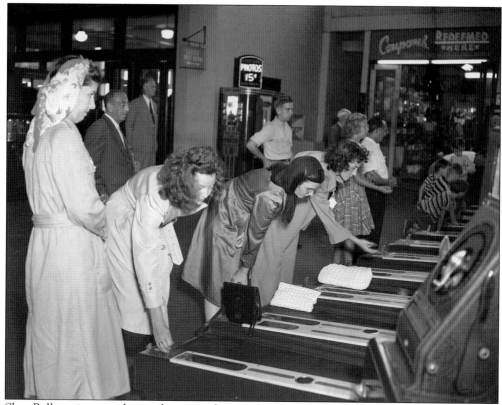

Skee-Ball was immensely popular everywhere at the Shore in the 1950s. Women and young boys in the Palace Amusements Arcade put nickels in a slot to release 10 wooden balls. They rolled the balls up an incline toward holes marked with point scores. The machines spat out rows of tickets redeemable for gifts. (Courtesy of Dorn's Classic Images.)

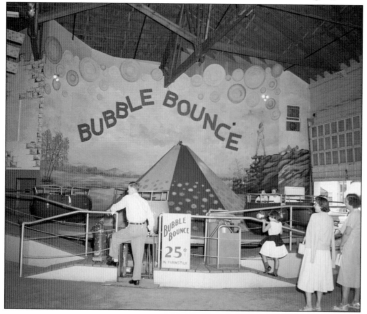

A young girl waits her turn on the Bubble Bounce inside Palace Amusements. Small cars with central steering wheels were mounted on a giant revolving dish. As one side of the dish moved up, the other went down. The Palace had dozens of such rides over many years. (Courtesy of Dorn's Classic Images.)

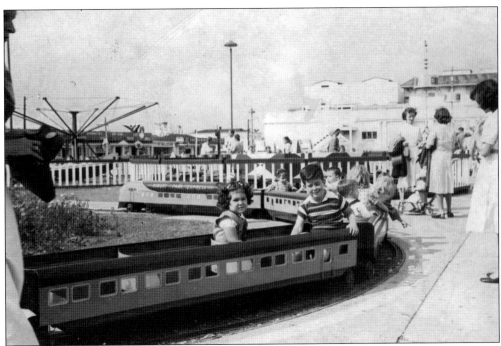

During the summer of 1949, future Monmouth County historian Randall Gabrielan (foreground in striped shirt) and his sister Carol ride the Asbury Park Express miniature train. The Gabrielan family was visiting the Shore from their home in Jersey City. The ubiquity of pictures of children on these train rides speaks to their popularity and endurance as fixtures at Jersey Shore amusement parks. (Courtesy of Randall Gabrielan.)

Based on how these adults are dressed, this picture must be from late spring or early fall in the 1950s. Neither weather nor time of year mattered to the thousands of children who delighted in the train rides at the Asbury Park boardwalk for decades. (Courtesy of Dorn's Classic Images.)

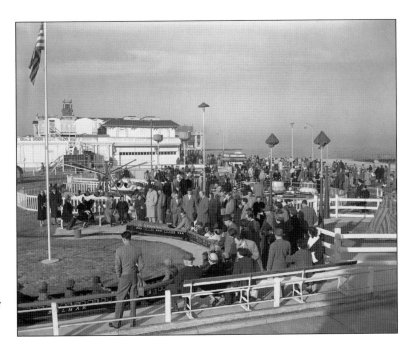

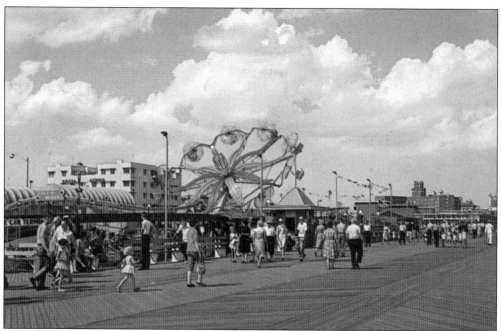

Bruce Springsteen's "4th of July Asbury Park (Sandy)" made it famous, but the Tilt-A-Whirl (left) and the Parachute Ride next to it on the boardwalk were enjoyed long before he released his song in 1973. The Albion Hotel is in the left background, the Berkeley Carteret Hotel to the far right. (Courtesy of Lisa Lamb.)

Seen here during the 1960s, Asbury Park was a bustling beach resort from Convention Hall (top right) to the casino (not shown). The boardwalk rides and attractions were busy day and night. (Courtesy of Rick Geffken.)

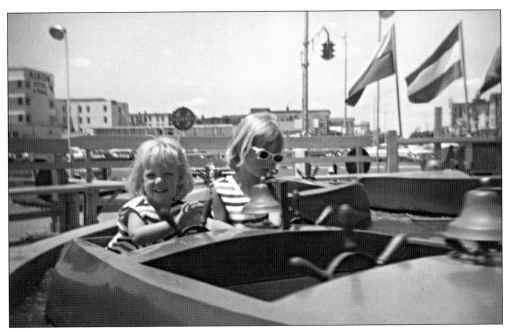

The Gates family of Union, New Jersey, took a day trip to Asbury Park in June 1965. Here, sisters Elaine (left) and Susan pilot a small boat on one of the boardwalk kiddie rides. Note the Garden State Parkway sign behind them. The Albion Hotel (left background) was located at Second and Ocean Avenues from 1940 until its demolition around 2000. (Courtesy of Gates family.)

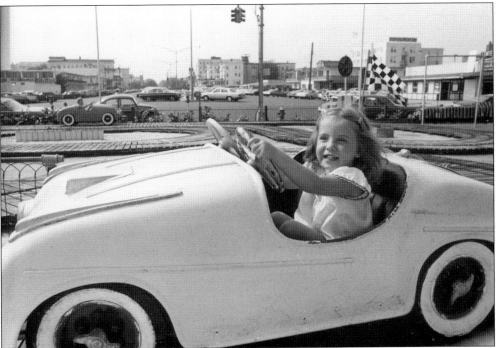

Michaela Cavallaro handles this Asbury Park car ride with joy and skill in 1974. Several kiddie rides were built where the Natatorium had been on the boardwalk. The building across the street to the right was Giulio's South Rock 'n' Roll bar at the time. (Courtesy of Chris Cavallaro.)

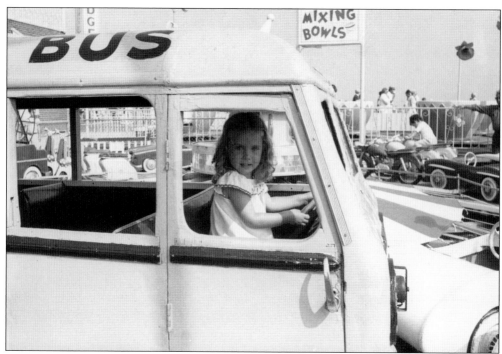

Michaela Cavallaro drives a miniature school bus at the boardwalk in 1974. The ride also had motorcycles, race cars, sedans, fire engines, and other imitation adult vehicles. The Mixing Bowls, a teacup ride for children, is in the background. (Courtesy of Chris Cavallaro.)

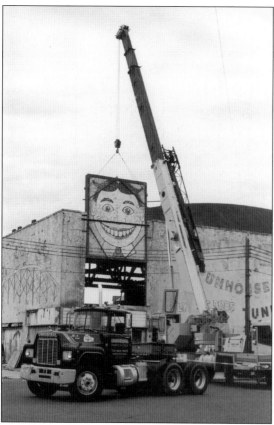

Tillie, emblematic symbol of Asbury Park since 1955, was removed from the facade of Palace Amusements in June 2004. George C. Tilyou's Coney Island Steeplechase Park and his Steeplechase Funny Place in Asbury Park had both used similar imagery. The demolition of the Palace Amusement Center felt like the end of an era to many people. (Courtesy of Randall Gabrielan.)

Joseph Ross opened a bathing house at the north end of Ocean Grove in 1877, seven years after the founding of the seaside town. His double-decker pavilion is in the center; bathhouses are on the left. Rope guides kept ocean bathers safe. (Courtesy of Historical Society of Ocean Grove.)

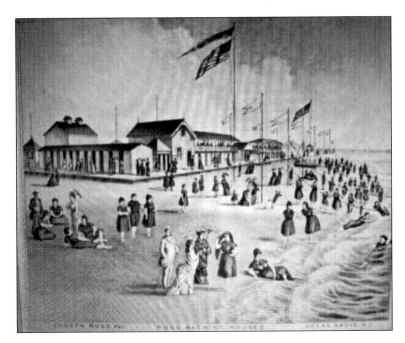

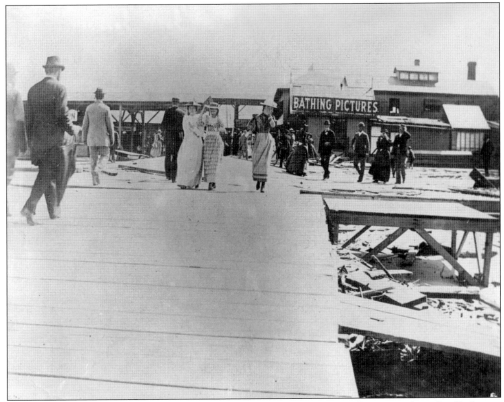

Ross's Pavilion (left) was an easy stroll from Asbury Park on this rudimentary boardwalk shown in 1885. The Pach Brothers, German immigrant photographers, operated the Bathing Pictures concession here and also in Long Branch. (Courtesy of Historical Society of Ocean Grove.)

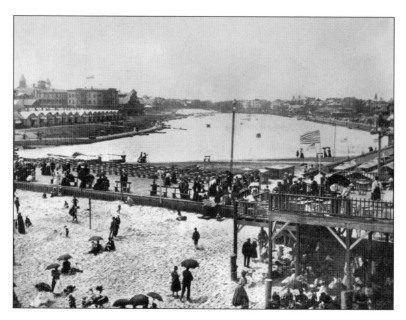

The Asbury Avenue Pavilion deck (right) on the north side of Wesley Lake is visible in this c. 1903 scene. The Ocean Grove Camp Meeting Association tents are on the south side. Canvas-topped boats are moored at the shoreline (left) behind rows of viewing benches. (Courtesy of Historical Society of Ocean Grove.)

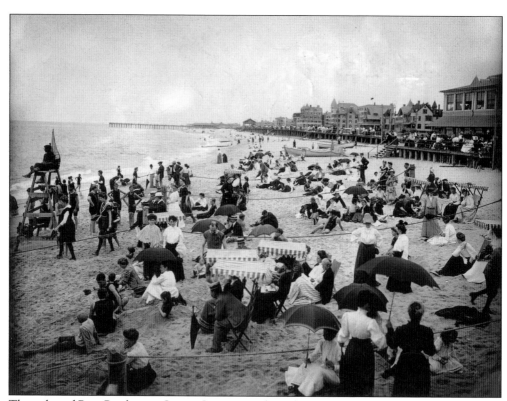

The enlarged Ross Pavilion in Ocean Grove is on the right. Bathers wear the modest clothing the era demanded. The fishing pier at the southern end of the boardwalk is visible in the background. The boardwalk connected the Ross Pavilion to Theodore W. Lillagore's Pavilion at the southern end of town by the time this 1905 picture was taken. (Courtesy of Library of Congress.)

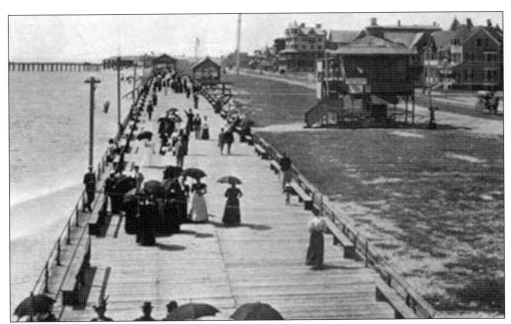

The building on stilts to the right of the Ocean Grove boardwalk housed a camera obscura, an early Jersey Shore amusement attraction. Author Stephen Crane recalled visiting it in 1892. A reflecting lens on top of the building beamed an image down to a rotating table in a small darkroom. Tourists delighted in spying on unsuspecting couples cuddling on the beach. (Courtesy of Jack and Beverly Wilgus Collection.)

The North End Pavilion in Ocean Grove (left) advertised "Hot & Cold Water Sea Baths" around 1912. An awning-covered walkway connected the pavilion to the North End Hotel (right) and the new Scenario Theater. A root-beer and ice-cream stand was between them. Note the "Merry-Go-Round" sign. Is "Storm" directing visitors to emergency routes from the ocean, or to another attraction? (Courtesy of Dorn's Classic Images.)

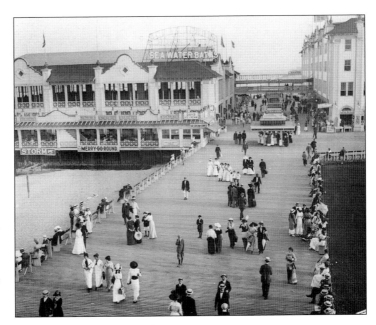

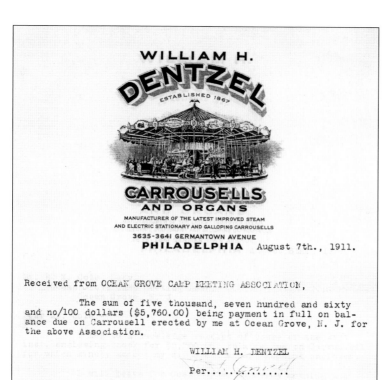

WILLIAM H.
DENTZEL
ESTABLISHED 1867

CARROUSELLS
AND ORGANS

MANUFACTURER OF THE LATEST IMPROVED STEAM
AND ELECTRIC STATIONARY AND GALLOPING CARROUSELLS

3635-3641 GERMANTOWN AVENUE
PHILADELPHIA August 7th., 1911.

Received from OCEAN GROVE CAMP MEETING ASSOCIATION,

The sum of five thousand, seven hundred and sixty
and no/100 dollars ($5,760.00) being payment in full on bal-
ance due on Carrousell erected by me at Ocean Grove, N. J. for
the above Association.

WILLIAM H. DENTZEL

Per...............

In 1911, the Ocean Grove Camp Meeting Association contracted famed Dentzel Carrousells to construct a merry-go-round behind the North End Hotel on Wesley Lake. The Philadelphia company was started by German master carver Gustav Dentzel. The Ocean Grove merry-go-round was direct competition to several Asbury Park merry-go-rounds. (Courtesy of Historical Society of Ocean Grove.)

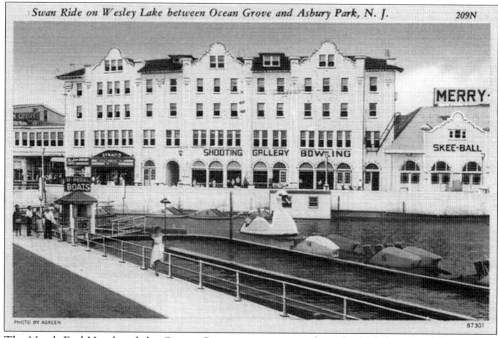

Swan Ride on Wesley Lake between Ocean Grove and Asbury Park, N. J. 209N

The North End Hotel and the Ocean Grove merry-go-round overlooked the U-Pedal boats and the Swan Ride on Wesley Lake. Rides on the merry-go-round cost 5¢ in the early years when the Bradley family leased the building. (Courtesy of Historical Society of Ocean Grove.)

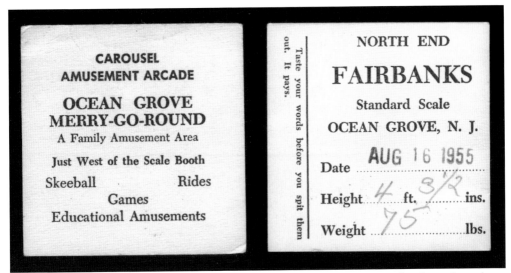

This 1955 ticket to the Ocean Grove merry-go-round includes a youngster's height and weight as recorded on a "standard scale." It advertises other nearby amusements and offers a pithy piece of advice in the center of the ticket. (Courtesy of Historical Society of Ocean Grove.)

Ocean Grove's Gail Greig photographed and published this image of the ornate horses in the Ocean Grove carousel. Carved chariots, cats, lions, giraffes, goats, deer, and even large rabbits attracted children and adults to the merry-go-round for almost 50 years. (Courtesy of Historical Society of Ocean Grove.)

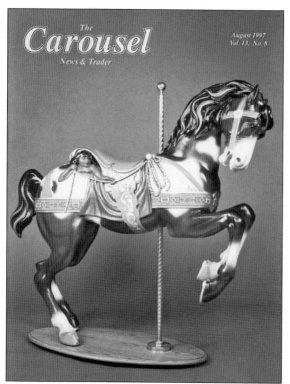

Years after the last rider of this Ocean Grove carousel horse climbed down from its saddle, this beautifully carved and polished Dentzel Prancer appeared on the cover of a niche publication. (Courtesy of Rock Hopkins/carouselhistory.com.)

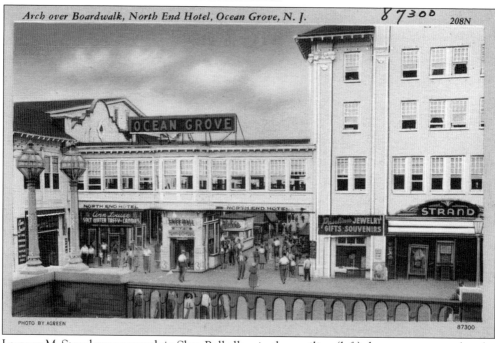

Layman M. Sternberg operated six Skee-Ball alleys in the pavilion (left) that was connected to the North End Hotel via a pedestrian walkway. When the hurricane of 1944 destroyed the pavilion, Sternberg relocated the alleys to the merry-go-round building (not shown) at 14 Lake Avenue. The Strand was formerly the Scenario Theater. (Courtesy of Boston Public Library.)

As befits a town founded on religious principles, the North End Hotel in Ocean Grove advertised an attraction called the Holy Land Quadorama. It may have been inspired by a three-dimensional diorama of Jerusalem displayed for years in town, or perhaps it was a rebranding of that diorama. (Courtesy of Historical Society of Ocean Grove.)

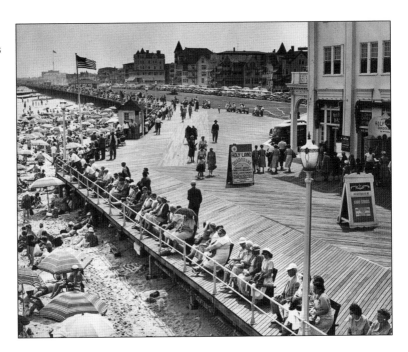

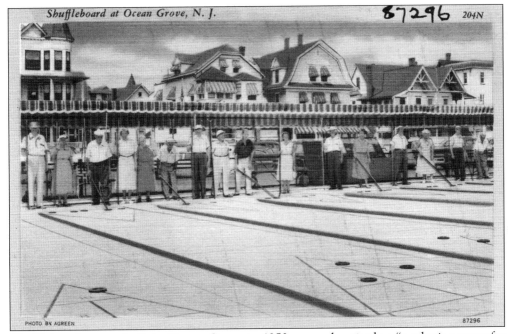

Shuffleboard courts built in Ocean Grove in 1950 were advertised as "a relaxing sport for older people." The Ocean Grove Shuffleboard Club hosted the First Annual New Jersey State Championship in 1961. (Courtesy of Boston Public Library.)

1944 HURRICANE

DAMAGE TO THE NORTH JERSEY COAST

PLAYGROUND OF EASTERN SEABOARD DEVASTATED

P-2015-6

The North End Pavilion at Ocean Grove was Left Battered and Hanging On a Wing and a Prayer

Most of These Pictures Were Made Either During the Storm or the Morning After

Address Mail Orders to LORENZO HARRIS, 133 Sylvan Ave., Asbury Park, N. J. Tel. A. P. 4196

The damage from the 1944 hurricane along the Jersey Shore was so devastating that newspapers ran special pictorial editions. This cover photograph shows what was left of the North End Pavilion in Ocean Grove. (Courtesy of Belmar Historical Society.)

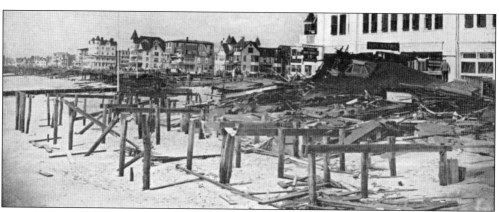

The Homestead Restaurant and the boardwalk in front of the North End Hotel were reduced to splinters by the 90-mile-per-hour winds and huge waves of the September 1944 hurricane. (Courtesy of *Asbury Park Press*.)

Four

BOARDWALK FUN
BRADLEY BEACH, BELMAR, MANASQUAN

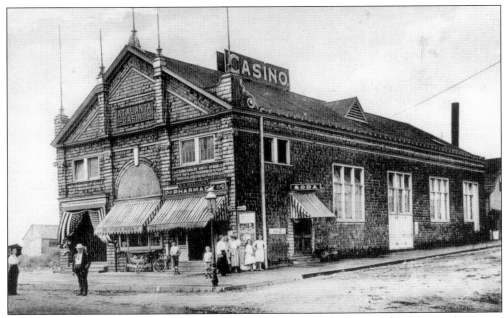

The Atalanta Casino in Bradley Beach opened around 1903 on the west side of Ocean Avenue at Newark Avenue. It featured vaudeville acts, card games, a pharmacy, and a soda fountain. It was later incorporated into the LaReine Hotel complex and renamed the LaReine Casino. (Courtesy of Randall Gabrielan.)

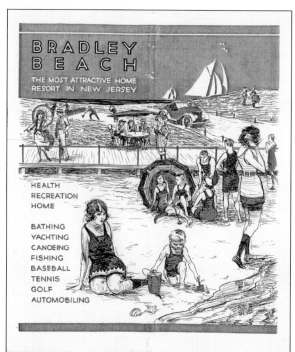

BRADLEY
BEACH
THE MOST ATTRACTIVE HOME
RESORT IN NEW JERSEY

HEALTH
RECREATION
HOME

BATHING
YACHTING
CANOEING
FISHING
BASEBALL
TENNIS
GOLF
AUTOMOBILING

James A. Bradley, who had developed Asbury Park, acquired another 54 acres along the oceanfront in 1871, which he called Bradley Beach. Each spring, the town distributed an advertising brochure supported by realtors and other local businesses. This 1924 cover image promotes the family-friendly beach and is designed to appeal to people looking for a community with many healthy athletic activities. (Courtesy of Bradley Beach Historical Society.)

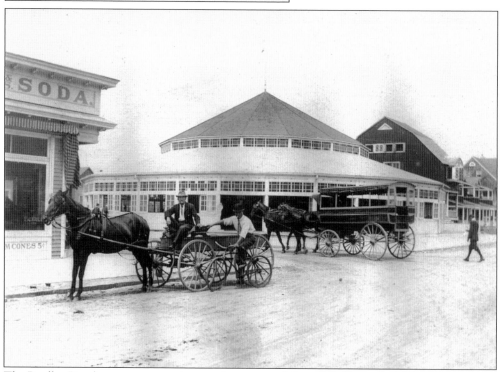

The Bradley Beach merry-go-round was at the corner of Ocean and Newark Avenues. Horses and carriages on the dirt road indicate this picture was likely taken around 1900, before automobiles became widely popular. The merry-go-round structure became Danceland in the 1920s. (Courtesy of Bradley Beach Historical Society.)

Unusual for its location, the Bradley Beach Bowling Alley was on the corner of Ocean and Newark Avenues. The image from 1917 suggests that the bowling alley dated from the turn of the century. (Courtesy of Bradley Beach Historical Society.)

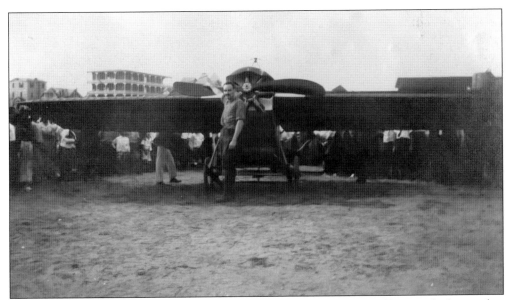

Royal Aero Club pilot George Miller Dyott holds his monoplane's propeller as onlookers gather around the aircraft in July 1913. Early pilot adventurers discovered that they could draw paying crowds to inspect their planes and take rides. (Courtesy of Bradley Beach Historical Society.)

Don't Fail to see the Dyott
MONOPLANE

that made the wonderful flight from New York to Bradley Beach

Now on exhibition.

Admission, including Souvenir Post Card, 10c.

Bradley Beach near Ocean Grove Pavilion

Bradley Beach's wide strand offered pioneering pilots like George Miller Dyott an inviting place to land. Dyott made a six-month tour of the United States in 1913. Summer vacationers and residents were drawn to see his single-engine, single-seat midwing monoplane, built in London as a sports and touring aircraft. (Courtesy of Bradley Beach Historical Society.)

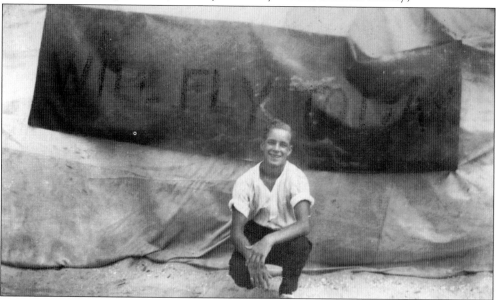

Dyott kept his plane on the beach in a canvas tent that sheltered the aircraft overnight, and served as a ticket booth and freestanding advertisement. An unknown young man about to take a flight crouches in front of the sign "Will Fly Today." (Courtesy of Bradley Beach Historical Society.)

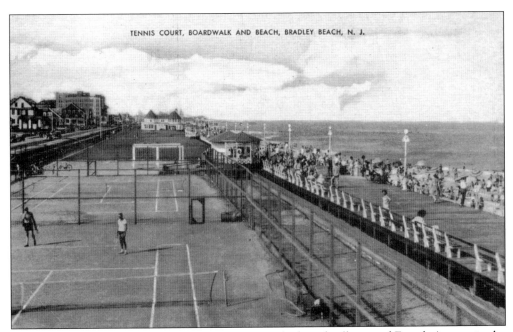

The Bradley Beach grass tennis courts were next to the boardwalk around Fourth Avenue in the 1920s when the sport was hugely popular. The multistory LaReine Hotel was on Ocean Avenue (left rear). Fun, sun, and tennis were among the hard-to-beat enticements drawing vacationers to the seaside community. (Courtesy of Bradley Beach Historical Society.)

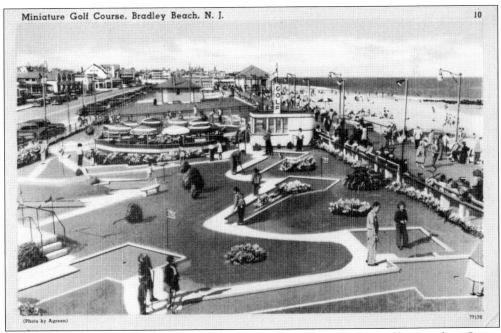

Miniature Golf Course, Bradley Beach, N. J. 10

(Photo by Agreen) 77170

Like many Jersey Shore communities, Bradley Beach had its own miniature golf course along Ocean Avenue. In the 1940s, this course had a picnic area under umbrellas and real grass ornamented with floral arrangements. Miniature houses and other golf hole obstacles popular today did not clutter this course. (Courtesy of Bradley Beach Historical Society.)

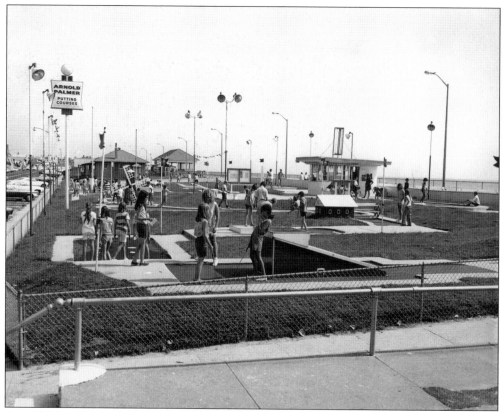

Arnold Palmer's success on the links made golf more popular than ever in America during the 1960s. Bradley Beach entrepreneurs took note and opened an Arnold Palmer Putting Course with a windmill and other features. Note that the golf kiosk in this picture is the same one as in the previous incarnation of miniature golf along the boardwalk. (Courtesy of Bradley Beach Historical Society.)

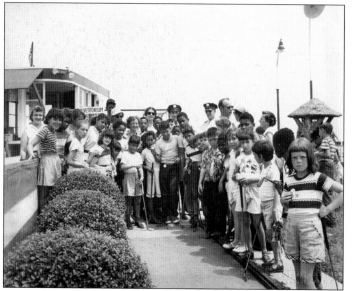

Children from the Farmingdale Preventorium visited Bradley Beach for a recreation and golf outing on a 1960s summer day. The youngsters, who had been near people suffering from tuberculosis, were temporarily quarantined so they would not contract the highly infectious disease. (Courtesy of Bradley Beach Historical Society.)

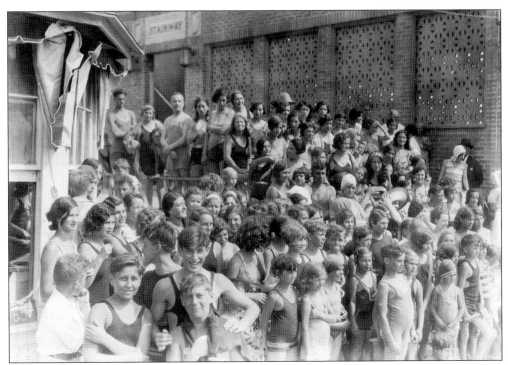

Swimming pools were the attractions Bradley Beach children loved the most during summers. In this c. 1930s picture, children line up to receive their bathing tags. A couple of boys at the bottom left seem less interested in swimming and more interested in girls. (Courtesy of Bradley Beach Historical Society.)

These 1960s youngsters loved the pool despite being close to the ocean, visible through the windows. Would they have paid much attention to the warning sign on the right? (Courtesy of Bradley Beach Historical Society.)

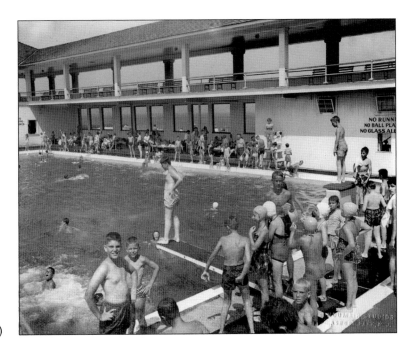

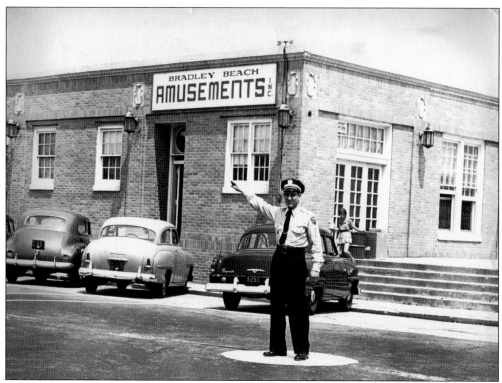

Pinball, Skee-Ball, cards, and other games of chance were all part of the Bradley Beach Amusements. The relatively small beach resort was so popular that a cop was necessary to direct traffic on Ocean Avenue during the summer. The cars suggest this was taken between 1945 and 1954. (Courtesy of Bradley Beach Historical Society.)

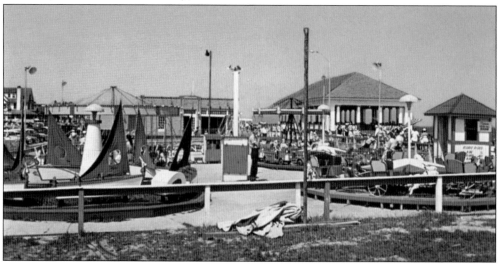

Bradley Beach had more than swimming and miniature golf. The Super Duper Kiddie Rides seen here were essential to any Jersey Shore family resort. Revolving sailboats, a miniature carousel, horse and buggy rides, and a fire truck were the usual standards. The Bradley Beach Amusements building shown in the previous picture is in the center of this one. (Courtesy of Bradley Beach Historical Society.)

Longtime Bradley Beach resident Josephine Hopkins and her grandson Charlie inspect the damage to the beachfront caused by the December 1992 nor'easter. The Jersey Shore was severely eroded by the accompanying high tides, which destroyed boardwalk businesses. The worst storm in 30 years caused the total loss of this Fifth Avenue Boardwalk Beach Depot. (Courtesy of Bob Hopkins.)

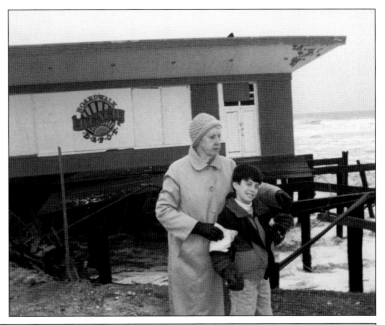

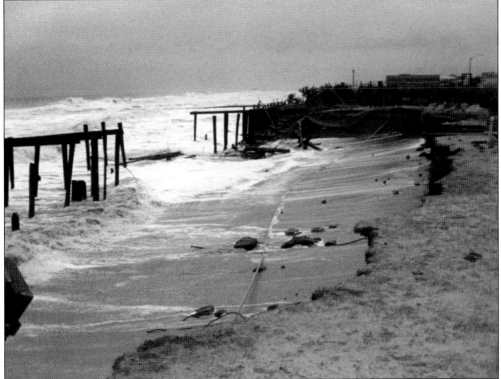

Bradley Beach and Belmar sustained the largest amount of damage along the Shore in December 1992. Both towns rebuilt their boardwalks before the start of the summer season of 1993. Belmar opted for replacing the old wooden one with stronger materials like Trex. Bradley Beach, pictured here, replaced its boardwalk with paving tiles, which proved the better choice when Superstorm Sandy swept through two decades later. (Courtesy of Bob Hopkins.)

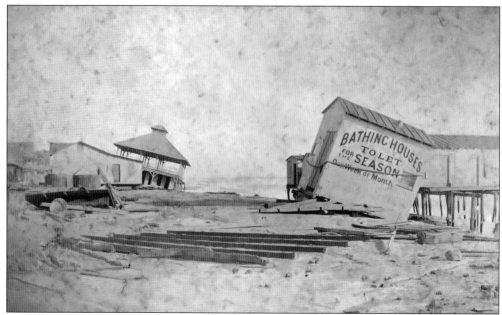

Dozens of storms and hurricanes have battered the Jersey Shore since it developed into a prime recreational area in the 19th century. This photograph shows the destruction suffered at Belmar's Tenth Avenue Pavilion and Bathing Houses after a storm in 1890, the same year the 1.6-square-mile borough acquired its name. (Courtesy of Belmar Historical Society.)

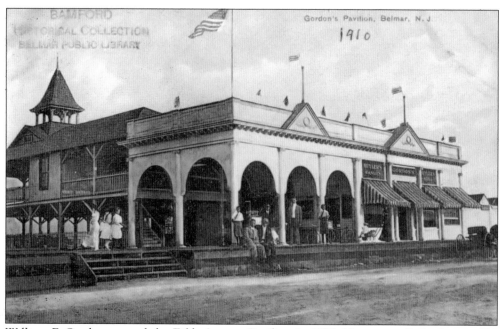

William F. Gordon opened the Fifth Avenue Pavilion in 1894. He eventually built over 300 bathhouses and many stores such as a souvenir shop, a barbershop, and a photo gallery. (Courtesy of Belmar Historical Society.)

Before the turn of the 20th century, the amusement ride called Shoot the Chutes was at the corner of Fifth and F Streets, close to the Atlantic Coast Electric Railway tracks. Patrons took small flat-bottomed boats from the top platform and coasted down the long incline across a lagoon. A cable system brought the boats back to the top of the platform. (Courtesy of Belmar Historical Society.)

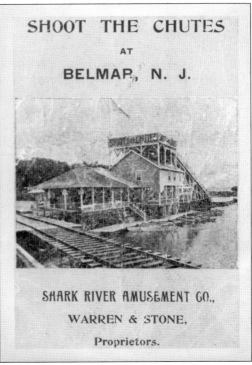

Thomas J. Murphy built the Belmar Casino at Fifth Avenue and F Street in 1902. Built on the Shark River, it had billiard rooms, a bowling alley, and shuffleboard courts. This 1910 drawing shows the Atlantic Coast Electric Railway's trolley tracks on the Main Street Bridge (foreground) and a train on the railroad bridge (background right). Klein's Restaurant and Fish Market is on the site today. (Courtesy of Belmar Historical Society.)

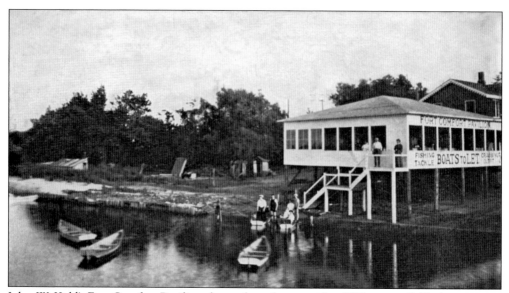

John W. Kidd's Fort Comfort Pavilion, located on the east side of F Street at Fifth Avenue, was known as Captain Kidd's Pavilion and Boathouse. Kidd offered refreshments, rowboat rentals, box ball alleys, a shooting gallery, and other attractions into the late 1920s. Havens & Hampton Sea Food Market subsequently occupied the site for many years. A condominium complex is at the riverfront spot today. (Courtesy of Belmar Historical Society.)

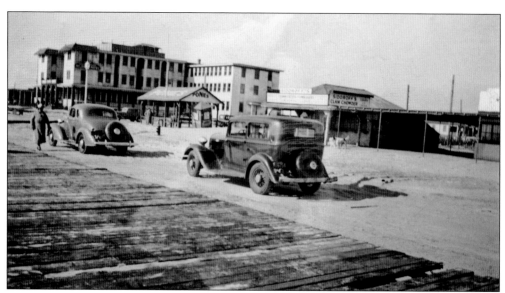

In the 1930s, Rulif Brower opened a pony ride business at Ocean and Fifteenth Avenues between the Atlantic Hotel (left) and Theodore "Pop" Sidoroff's chowder stand (right). Brower had another pony ride at Wesley Lake in Asbury Park. (Courtesy of Belmar Historical Society.)

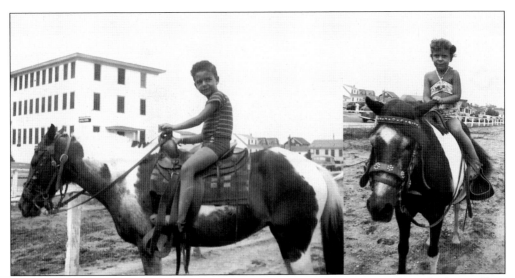

Rickey Stein (left) and his sister Susan spent every summer from 1944 through their college years living in a Belmar rental house on Sixteenth Avenue with their parents. Here they are, in August 1946, on the pony ride track just around the corner from their house. (Courtesy of Rickey Stein.)

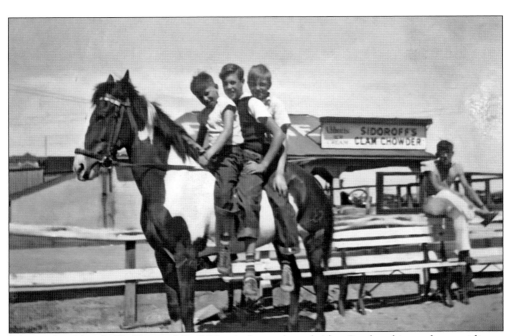

Johnny Conklin (left), George "Gig" Morris (center), and Alex Brodowski are shown riding a pinto pony named Clover during the summer of 1937. Years later, Morris started a successful florist shop in town. (Courtesy of Belmar Historical Society.)

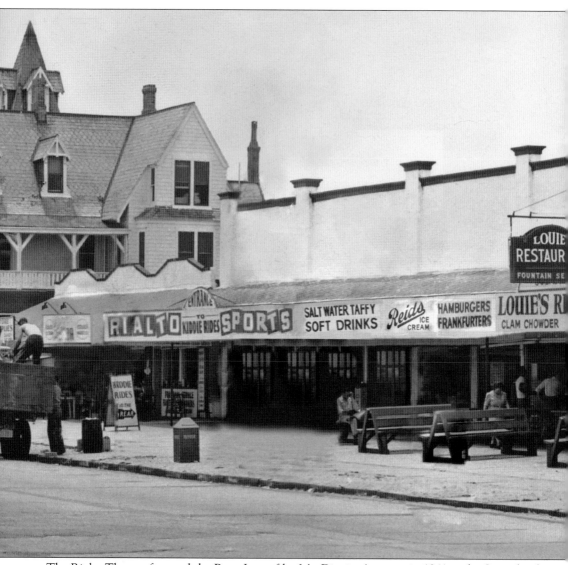

The Rialto Theatre featured the Peter Lorre film *Mr. District Attorney* in 1941 at the Sportsland complex between Eighth and Ninth Avenues on Ocean Avenue. It was on the site of an old merry-go-round, of which no pictures survive. The large pole—still there—in front of the Rialto

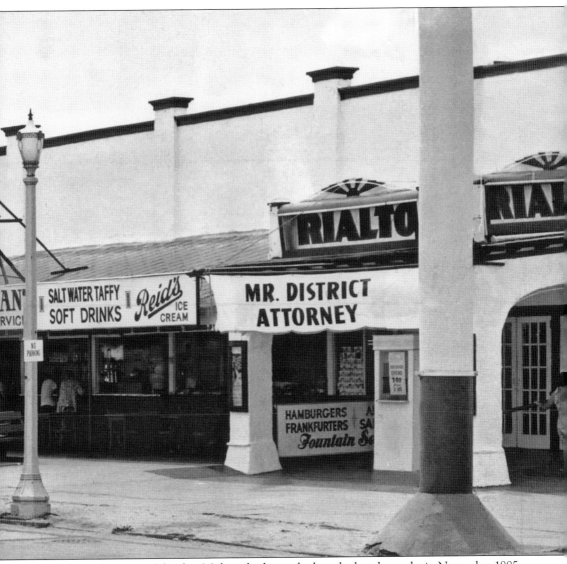

is actually the foremast of the ship *Malta*, which wrecked on the beach nearby in November 1885. (Courtesy of Ken Pringle.)

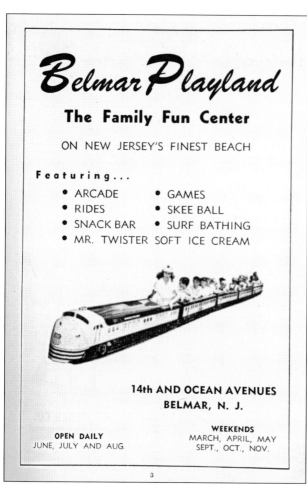

Belmar Playland

The Family Fun Center

ON NEW JERSEY'S FINEST BEACH

Featuring...

- ARCADE
- GAMES
- RIDES
- SKEE BALL
- SNACK BAR
- SURF BATHING
- MR. TWISTER SOFT ICE CREAM

14th AND OCEAN AVENUES
BELMAR, N. J.

OPEN DAILY
JUNE, JULY AND AUG.

WEEKENDS
MARCH, APRIL, MAY
SEPT., OCT., NOV.

3

Julius Schwartz opened Belmar Playland in the early 1970s. This advertisement in the chamber of commerce's *Official Guide to Belmar* tempted patrons with a snack bar and soft ice cream as well as typical Jersey Shore arcade games and a miniature train ride. Amusement centers and food concessions continued at the Fourteenth Avenue location for 50 years. (Courtesy of Belmar Historical Society.)

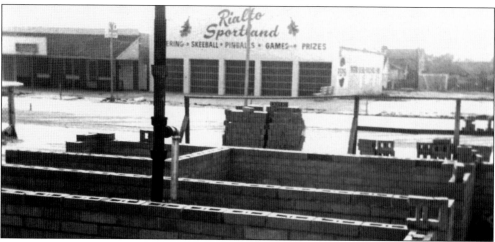

The former site of the Rialto Theatre was an empty lot during boardwalk construction in April 1969. Rialto Sportland (called the "Penny Arcade" by local kids because most of its machines took pennies) became Fairlane Sportland Arcade in 1973, when Julius Schwartz opened Belmar Playland at Fourteenth Avenue. (Courtesy of Rickey Stein.)

During the 1940s and 1950s, Belmar sponsored "Surfside Serenades" at the Thirteenth Avenue Pavilion (now gone) on the boardwalk. Attendees were given songbooks like the one pictured here, with the lyrics to popular ballads of the day. An organ player accompanied the sing-alongs. (Courtesy of Belmar Historical Society.)

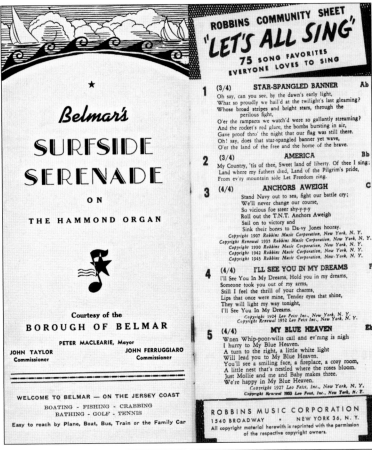

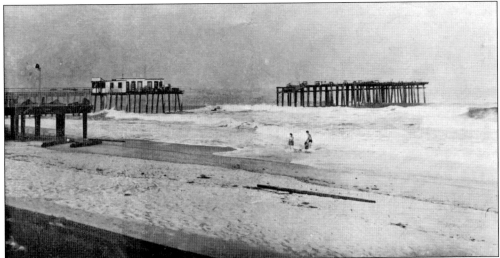

A September 1944 hurricane carried away 100 feet of the Belmar Municipal Fishing Pier at Sixteenth and Ocean Avenues. Winds recorded at 74 miles per hour destroyed a mile of boardwalk as well. Belmar's losses totaled $400,000, or over $5.5 million today. (Courtesy of Belmar Historical Society.)

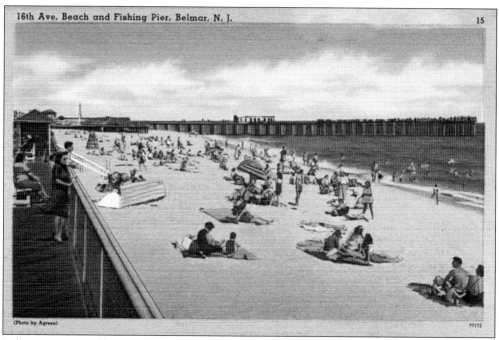

(Photo by Agreen) 77172

Belmar entertained bids for the rebuilding of the municipal fishing pier. The gap was repaired and new pilings were added in time for the 1945 season, as shown in this Tichnor Brothers postcard from a few years later. (Courtesy of Belmar Historical Society.)

"THE DECK"
16th Avenue and Boardwalk, Belmar, N. J.
18 HOLES OF OBSTACLE GOLF . . . 15c
MINIATURE GOLF GAMES— Unique . . . On the Boardwalk in the open . . .

Belmar postmaster Everett H. Antonides operated a miniature golf course on the boardwalk at Sixteenth Avenue in the early 1940s. After over 50 years of operation, it went out of business after it was destroyed by the nor'easter of 1992. (Courtesy of Belmar Historical Society.)

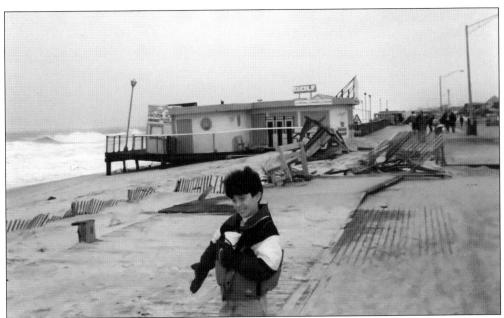

Twelve-year-old Charlie Hopkins of West Allenhurst stands on the remains of the totally destroyed boardwalk near the miniature golf location in Belmar after the storm of December 11–12 in 1992. The golf amusement was never rebuilt. The churning waves in the background were two to three times higher during the actual nor'easter. (Courtesy of Bob Hopkins.)

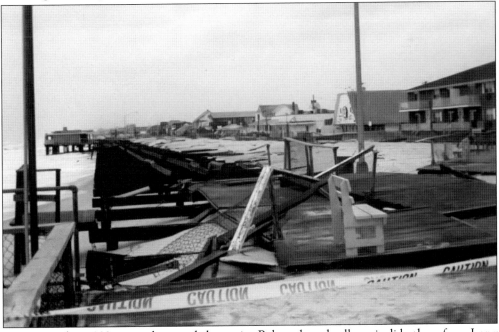

The December 1992 storm destroyed the entire Belmar boardwalk, as it did others from Long Branch to Spring Lake. It was a huge and costly operation to haul all the wood and debris away and to replace the boardwalk in only a few months. D'Jais (low white building) and Mamaluke's (mansard-roofed structure to right) survived serious flooding and reopened by the following summer. (Courtesy of Bob Hopkins.)

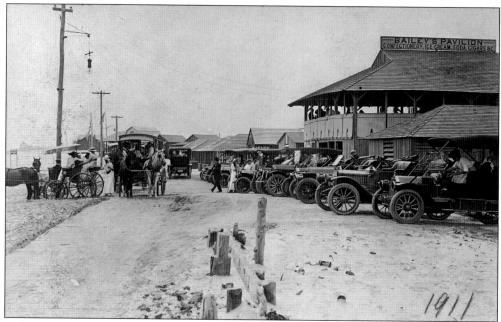

William H. Bailey's Pavilion on Manasquan Beach is shown in the fall of 1911 during the annual Big Sea Day. The celebration started in the 19th century when hundreds of farmers and their families traveled in horse-drawn carriages to the ocean for bathing, frolicking, picnicking, and dancing. (Courtesy of Squan Village Historical Society.)

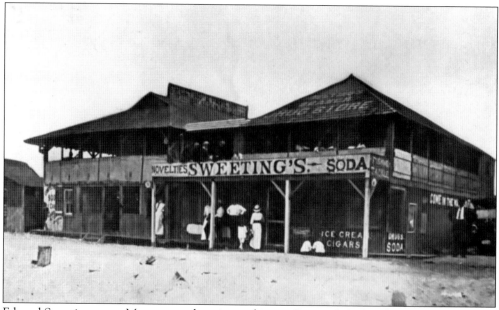

Edward Sweeting was a Manasquan druggist working at Burroughs's Apothecary Company. He owned a dance hall, drugstore, and a novelty and sweet shop on the beach at the Brielle Road. In 1914, he bought Bailey's Pavilion and its 160 bathhouses, changed the name, and moved his dance hall building next to it. With that, Sweeting controlled the only amusement pavilions on Manasquan Beach. (Courtesy of Squan Village Historical Society.)

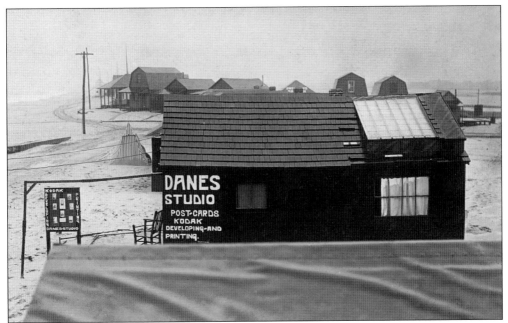

Odd as it seems in these days of digital images on mobile phones, in the early 20th century, photography studios were considered an amusement for tourists visiting beachfront communities. Dane Metcalf opened a Kodak Film business on Squan Beach around 1900, near the Brielle Road (just behind his studio). Those are decidedly not solar panels on his roof—most likely ordinary glass panes. (Courtesy of Squan Village Historical Society.)

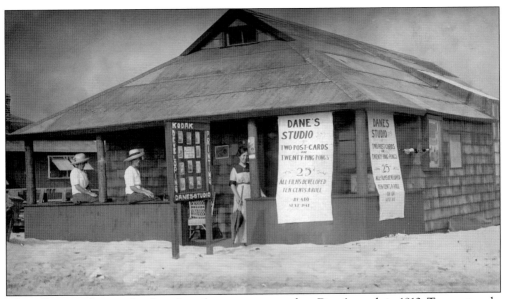

Film rolls cost a dime to develop when these women posed on Dane's porch in 1912. Two postcards, made from tourists' pictures, could be had for 25¢. The "twenty ping pongs" for sale were the now-familiar little white celluloid balls used in table tennis. The game was invented just a few years earlier and was sweeping the country. (Courtesy of Squan Village Historical Society.)

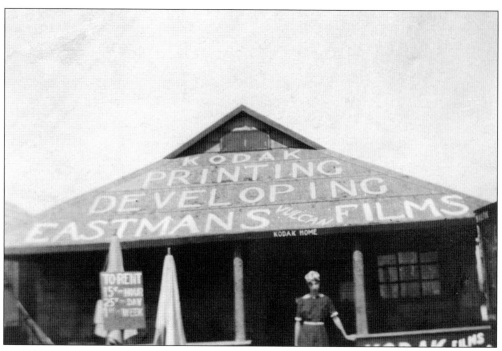

Dane's location on Manasquan Beach was the perfect spot to cater to needs of leisurely vacationers. Besides selling and developing film as part of the new amusement fad of casual photography, he rented umbrellas for 15¢ per hour or 25¢ per day. (Courtesy of Squan Village Historical Society.)

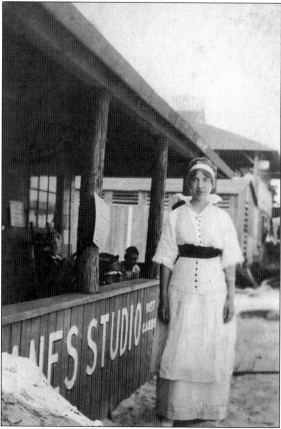

May Cripps, probably one of Dane Metcalf's Studio employees, poses in front of Dane's Studio in 1912. The two-story Bailey's Pavilion is visible behind her and to the right. (Courtesy of Squan Village Historical Society.)

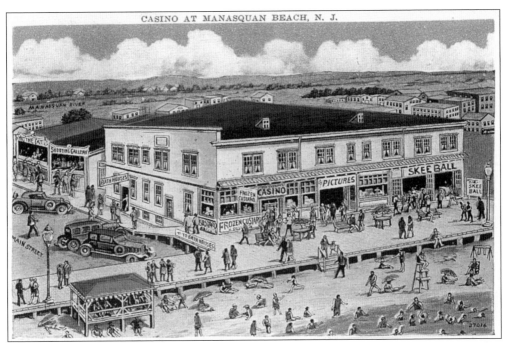

The Manasquan Beach Casino was at the boardwalk at the foot of Main Street. Skee-Ball and other amusements lured beachgoers who craved frozen custard, bought pictures, and tried their skills at a shooting gallery. Originally operated by the Seyfried family, the casino became Resnick's and then Gee Gee's. Note the slightly exaggerated open country and farm views in the background. (Courtesy of Squan Village Historical Society.)

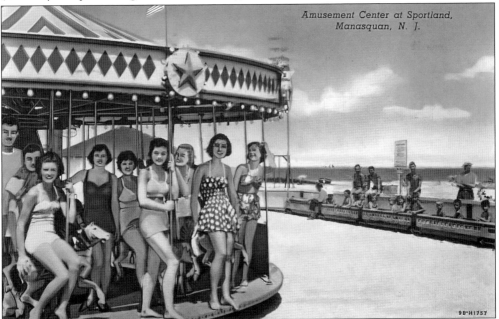

Amusement Center at Sportland, Manasquan, N. J.

Serial entrepreneur Irving B. Kirsch owned many Shore businesses, including Sportland at Manasquan Beach, which had a small carousel and miniature train ride. Sportland also included a Ferris wheel and kiddie boat rides. (Courtesy of Squan Village Historical Society.)

During the 1960s, when this couple sat on a bench along the North Jersey Shore's only paved "boardwalk," Joseph Resnick operated the arcade at Main Beach, Manasquan. Local teenager Joel Lemansky remembers removing dozens of the old bathhouses under the building some years later. Resnick's was renamed Gee Gee's after George Garabedian bought it. (Courtesy of Chris Cavallaro.)

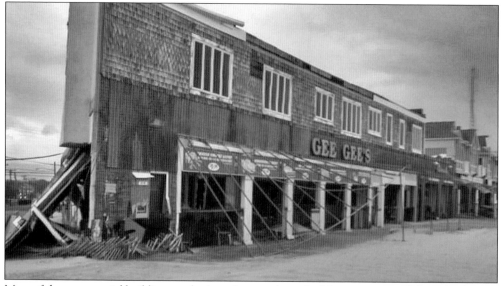

Most of the commercial buildings and private homes along the Manasquan Beach boardwalk were total losses after Superstorm Sandy barreled through in October 2012. Gee Gee's was destroyed. The Arcade in the previous picture is the one-story building to the right of Gee Gee's. (Courtesy of Rickey Stein.)

Five

THEME PARKS
STORYLAND VILLAGE, JERSEY JUNGLE, COWBOY CITY

Storyland Village opened on Highway 35 at the Asbury Park Circle in June 1955. Built by New York garment manufacturer Max Kohlmer, the 54-acre park was actually in Neptune where Seaview Square Mall is today. It was advertised as "a child's garden of verse and stories come to life." It featured nursery rhymes, popular songs, and Biblical themes among its attractions. (Courtesy of Randall Gabrielan.)

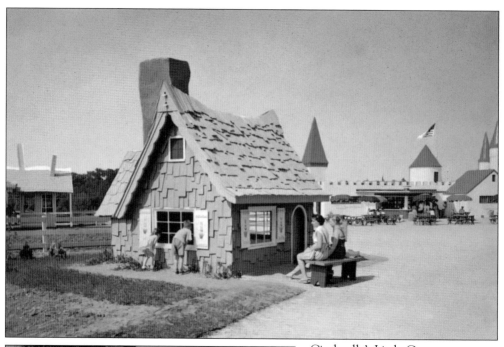

Cinderella's Little Cottage was just inside the front entrance to Storyland Village. It was one of the child-sized structures that made the park so popular during its relatively short existence. (Courtesy of Rick Geffken.)

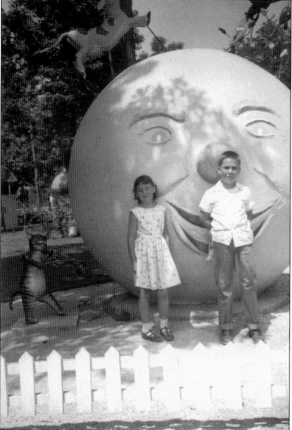

Nancy and her brother (coauthor) Rick Geffken are pictured in July 1956 in Storyland Village in front of a scene inspired by the Mother Goose verse "Hey diddle diddle, / The Cat and the Fiddle, / The Cow jumped over the Moon." (Courtesy of Mary Geffken.)

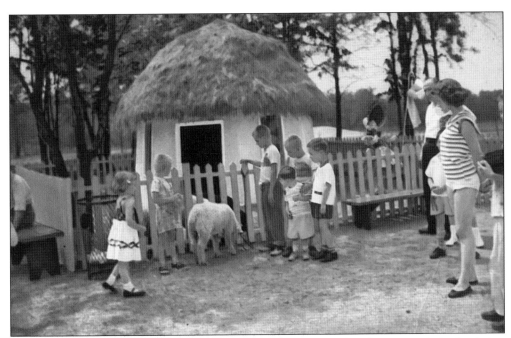

The American illustrator and scenic designer Russell Patterson played a major role in the design of Storyland Village, using 30 mostly old English nursery rhymes as themes. Among them was the well-known "Little Bo Peep." Children loved the live animals at the displays, most especially the live sheep "found" at Little Bo Peep's cottage. (Courtesy of Randall Gabrielan.)

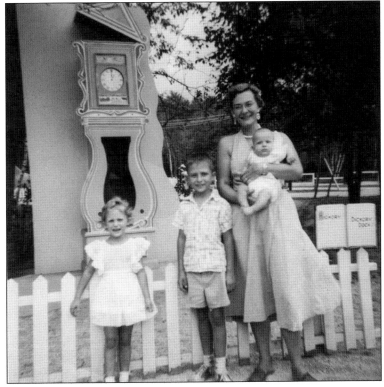

Lisa, Chris, and baby Carl Cavallaro and their mother, Marge, visited Storyland Village around 1955. Here, they pose in front of "Hickory, dickory, dock / The mouse ran up the clock." The mouse is not in this picture, but the first verses of the rhyme are shown in the book next to them. (Courtesy of Chris Cavallaro.)

During a visit to Storyland Village in July 1956, Rick and his sister Nancy Geffken pose for their father, George, outside this fanciful portico. The towers in the background are referencing the story of Rapunzel. (Courtesy of Mary Geffken.)

The Davy Crockett craze swept America as part of *Walt Disney's Disneyland* television show in 1954 and 1955. Storyland Village joined the frenzy, while trying to steer clear of copyright infringement. Seven-year-old Chris Cavallaro of Metuchen, appropriately outfitted in the signature Crockett coonskin cap, is pictured outside a rough-hewn cabin in the "Frontier City" section of Storyland Village. (Courtesy of Chris Cavallaro.)

Pony rides were favorites for 1950s baby boom children. Middle-class family traditions in those days often included automobile rides after church on Sundays to places featuring the kid-sized animals. This Pony Track was in Storyland Village in Neptune. (Courtesy of Randall Gabrielan.)

Seven-year-old Nancy Geffken looks on tentatively as her brother Rick feeds one of Santa's reindeer at Storyland Village. The park was part live nursery rhyme roadside attraction and part petting zoo. (Courtesy of Mary Geffken.)

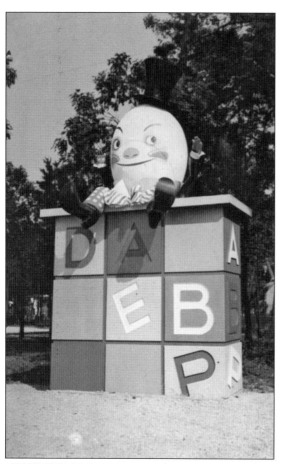

One of the best-known childhood verses re-created at Storyland Village is this one: "Humpty Dumpty sat on a wall / Humpty Dumpty had a great fall." This representation of the famous egg man sits atop a wall of oversized children's blocks. (Courtesy of Randall Gabrielan.)

Jonah and the Whale was next to the Gingerbread House. Though the story of Jonah is from the Old Testament, Storyland Village's owners thought most 1950s children would not distinguish Bible stories from nursery rhymes. (Courtesy of Randall Gabrielan.)

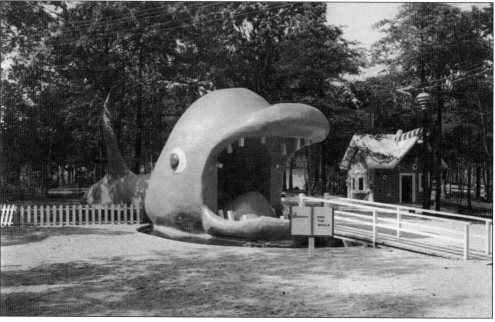

Rick Geffken points to Jonah on the tongue of the whale while his younger sister Nancy poses patiently. Ramps like this one allowed children to get close to and inside the various scenes at Storyland Village. (Courtesy of Mary Geffken.)

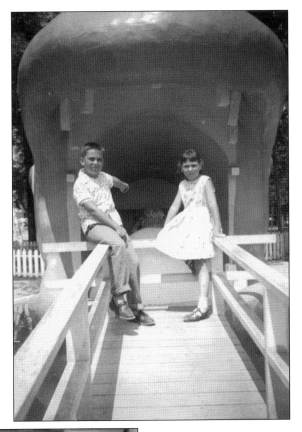

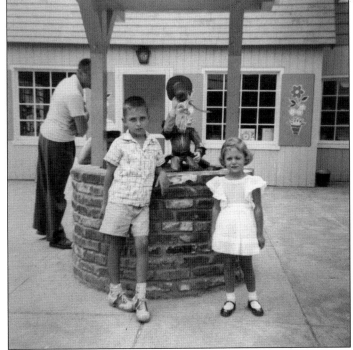

Chris and Lisa Cavallaro pose at a replica well at Storyland Village around 1955. The character waving the hat behind them may be one of these mentioned in the nursery rhyme: "Ding, dong, bell / Pussy's in the well / Who put her in / Little Johnny Flynn / Who pulled her out / Little Tommy Stout." Storyland Village lasted for almost 10 years, finally closing in 1964. (Courtesy of Chris Cavallaro.)

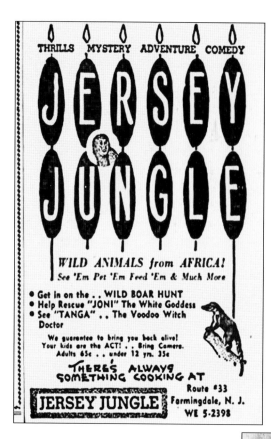

THRILLS MYSTERY ADVENTURE COMEDY

JERSEY JUNGLE

WILD ANIMALS from AFRICA!
See 'Em Pet 'Em Feed 'Em & Much More

● Get in on the . . WILD BOAR HUNT
● Help Rescue "JONI" The White Goddess
● See "TANGA" . . The Voodoo Witch
 Doctor

We guarantee to bring you back alive!
Your kids are the ACT! . . Bring Camera.
Adults 65¢ . . under 12 yrs. 35¢

THERE'S ALWAYS
SOMETHING COOKING AT

JERSEY JUNGLE
Route #33
Formingdale, N. J.
WE 5-2398

Earl E. Collins opened Jersey Jungle around 1957 as a small roadside attraction in Howell (despite advertisements indicating Farmingdale). The "Wild Animals from Africa" were actually caged llamas, sheep, pigs, and monkeys. Tanga was an African American actor dressed as a witch doctor, reinforcing contemporary misconceptions about Africa and its people. The small entertainment park lasted just a few years. (Courtesy of *Asbury Park Press*.)

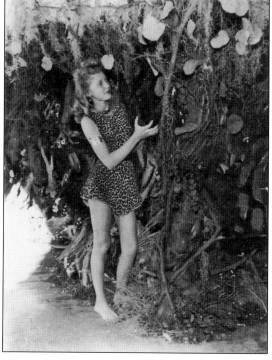

The daughter of one of Jersey Jungle's owners played the role of Jungle Joni, "the White Goddess." Here, she is holding her barely visible pet monkey Koko in a tree wrapped with simulated jungle vines. Visiting kids went on safaris "to capture wild boars," which were actually just miniature pigs. Souvenirs like tom-toms and rubber spears supported the jungle illusion. (Courtesy of *Weird NJ*.)

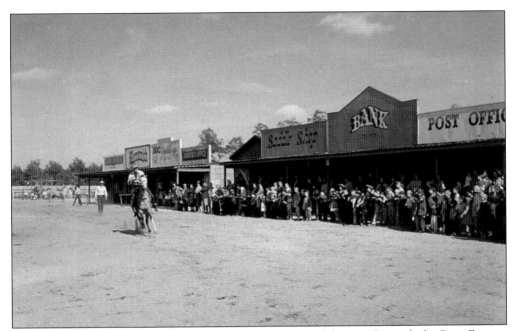

Standing at the hitching posts in Cowboy City in Farmingdale, crowds watch the Pony Express rider coming into town. Buildings pictured include Doc Giddings Dentist, the Saddle Shop, Bank, and Post Office as well as a Print Shop where Wanted, Dead or Alive posters with guests' pictures were sold. (Courtesy of Kate Mellina.)

After he worked at the pony and goat rides for several summers, Mike Romano became an official "cowboy" when he became 18. Here, he poses on horseback in front of Indian teepee poles. Paid less than a dollar an hour in the 1960s, Romano still recalls the fun he had with the other cowboys and cowgirls: "A great summer job for a city kid from Bayonne." (Courtesy of Mike Romano.)

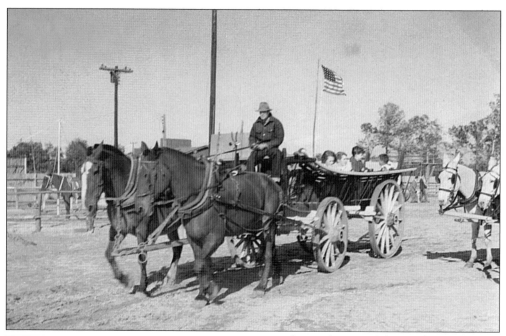

Original owners John Anders and Lou Shaw hired actors to re-create classic scenes from decades of popular Hollywood cowboy movies. Cowboy City had hay wagons (seen here), pony rides, goats pulling two-wheeled buggies, cows, horses, the Pony Express, and stagecoaches. (Courtesy of Kate Mellina.)

When Mike Romano of Bayonne, New Jersey, spent summers at his grandparents' house in Farmingdale, he worked at Cowboy City from 1958 through 1961. Many local boys played roles at the park. They were given little training and simply told to act like cowboys. Here, the 17-year-old Romano poses with his handy six-shooter outside the Cowboy City jail. (Courtesy of Mike Romano.)

Cowboy City owners recruited tribal members from the Kahnawake territory of the Mohawk Nation in the Canadian province of Québec and also Senecas from an Iroquoian-speaking group. During the heyday of Cowboy City, Native American tribes were not recognized as distinct from one another, but simply as one contiguous group of people. These two "genuine American Indians" were not identified. (Courtesy of Kate Mellina.)

Besides cowboy hats, Indian headdresses, toy guns, and other western bric-a-brac, visitors to Cowboy City could purchase ashtrays like this one. Although it shows Cowboy City in Farmingdale, the amusement park was actually in nearby Howell on New Jersey Highway 33 (as noted in the lower left and right inscriptions). Cowboy City changed owners several times before it finally closed in 1965. (Courtesy of Farmingdale Historical Society.)

BIBLIOGRAPHY

Adams, Arthur G. *The Hudson Through the Years*. New York: Fordham University Press, 1983.

Ayres, Shirley and Troy Bianchi. *Bradley Beach*. Portsmouth, NH: Arcadia Publishing, 2004.

Bell, Wayne T. *Ocean Grove*. Portsmouth, NH: Arcadia Publishing, 2000.

Boyd, Paul D. *Atlantic Highlands From Lenape Camps to Bayside Town*. Charleston, SC: Arcadia Publishing, 2004.

Brenner, Chris. "Highland Beach, Destinations Past." YouTube, 2015.

Futrell, Jim. *Amusements Parks of New Jersey*. Mechanicsburg, PA: Stackpole Books, 2004.

Gabrielan, Randall. *Long Branch: People and Places*. Charleston, SC: Arcadia Publishing, 1998.

King, John P. *Highlands: New Jersey*. Charleston, SC: Arcadia Publishing, 2001.

Lamb, Lisa. *Asbury Park Revisited*. Charleston, SC: Arcadia Publishing, 2015.

Lewis Historical Publications. *History of Monmouth County, New Jersey, 1664–1920*. New York: Lewis Historical Publications, 1922.

Murphy-Lupo, Stephanie. *Day Trips from New Jersey: Gateway Ideas for the Local Traveler*. Guilford, CT: Morris Book Publishing, 2012.

Roberts, Russell and Rich Youmans. *Down The Jersey Shore*. New Brunswick, NJ: Rutgers University Press, 2003.

Salvini, Emil R. *Boardwalk Memories: Tales of the Jersey Shore, Insiders' Guide*. Guilford, CT: Globe Pequot Press, 2006

Schnitzspahn, Karen L. *Jersey Shore Food History: Victorian Feasts to Boardwalk Treats*. Charleston, SC: History Press, 2012.

Troeger, Virginia Bergen and Robert J. McEwen. *Woodbridge: New Jersey's Oldest Township*. Charleston, SC: Arcadia Publishing, 2002.

About the
Organizations

We could not have written this book, or compiled the formerly unpublished photographs, without the help of the many historical societies at the Jersey Shore and the history rooms at local libraries. We urge our readers to visit and support the following organizations dedicated to preserving our history:

Asbury Park Historical Society	aphistoricalsociety.org
Atlantic Highlands Historical Association	ahhistory.org
Belmar Historical Society	belmarhistoricalsociety.org
Bradley Beach Historical Society	715 Main Street Bradley Beach, NJ 07720
Dorn's Classic Images	dornsclassics@gmail.com
Farmingdale Historical Society	13 Asbury Avenue Farmingdale, NJ 07727
Franklin Township Public Library	franklintwp.org
Historical Society of Highlands	highlandsnj.com
Historical Society of Ocean Grove	oceangrovehistory.org
Jersey Coast Heritage Museum	PO Box 3145 Sea Bright, NJ 07760
Long Branch Public Library	longbranchlib.org/local-history
Monmouth County Genealogy Society	PO Box 5, Lincroft, NJ 07738-0005
Monmouth County Historical Association	monmouthhistory.org
Shrewsbury Historical Society	shrewsburyboro.com/historical-society
Squan Village Historical Society	squanvillagehistoricalsociety.org
Woodbridge Public Library	woodbridgelibrary.org/local-history

DISCOVER THOUSANDS OF LOCAL HISTORY BOOKS FEATURING MILLIONS OF VINTAGE IMAGES

Arcadia Publishing, the leading local history publisher in the United States, is committed to making history accessible and meaningful through publishing books that celebrate and preserve the heritage of America's people and places.

Find more books like this at
www.arcadiapublishing.com

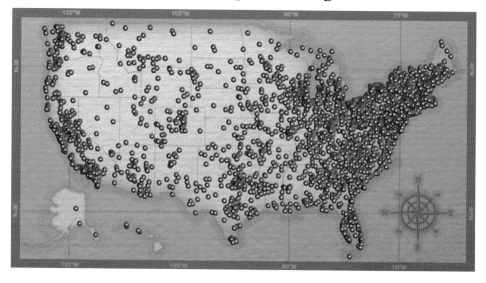

Search for your hometown history, your old stomping grounds, and even your favorite sports team.